To Samy
With Love,
Kerry

Christmas 1994

P9-DFS-835

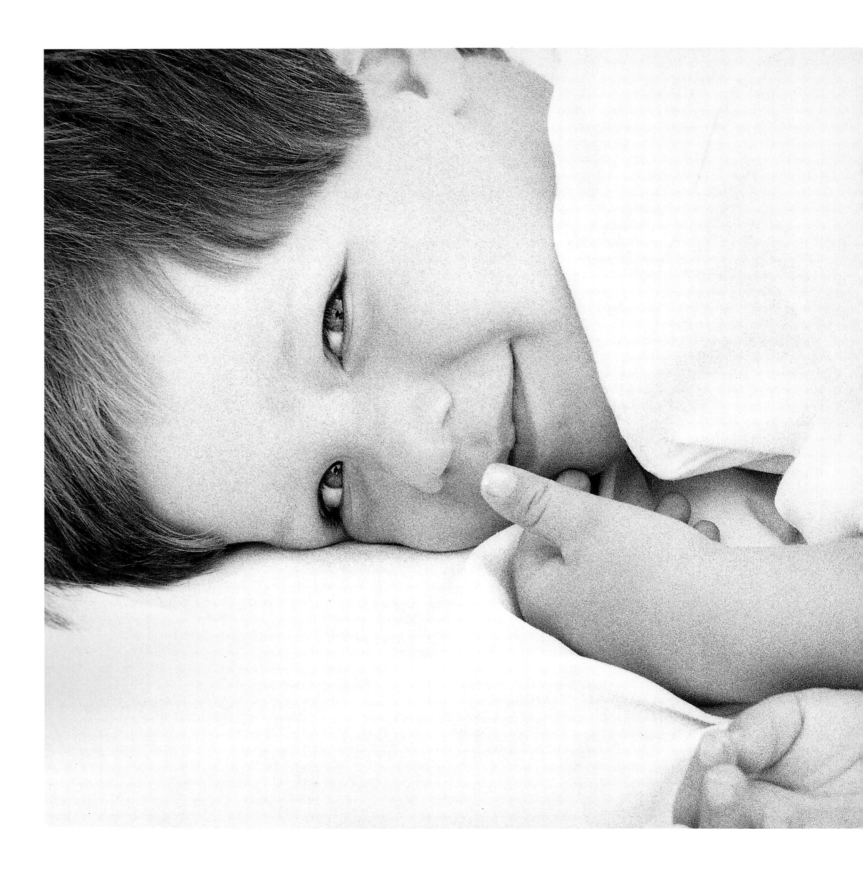

PORTRAITS OF LIFE

With Love

An Intimate Collection Of Exclusive Photographs Of Celebrities
With Their Personal Reflections On Life And Love

By

Joan Lauren

for the Hands On Care Foundation

Producer/Artist Coordinator

Bruce Harlan Boll

Foreword by

Elizabeth Glaser

General Publishing Group, Inc.
Los Angeles

Publisher: W. Quay Hays
Managing Editor: Sarah Pirch
Layout: Nadeen Torio and Joan Lauren

© 1994 by Hands On Care Foundation, Inc.

All photographs © 1994 by Joan Lauren

Joan Lauren, author/photographer, has donated her talent
to the Hands On Care Foundation for the making of this book.

All rights reserved under International and Pan-American Copyright Conventions.
This book, or any parts thereof, may not be reproduced in any fashion whatsoever
without the prior written permission of the publisher/photographer/HOCF.

For information:
General Publishing Group, Inc.
3100 Airport Avenue
Santa Monica, CA 90405

Printed in the USA
10 9 8 7 6 5 4 3 2 1

General Publishing Group
Los Angeles

With every charitable project, there are many unseen individuals without whose caring efforts the work would be overwhelming. It is the support behind the scenes that makes the magic and memories possible. Please take a moment and acknowledge those who have given of themselves for those who will directly benefit from the royalties of this book. It is with love and heartfelt appreciation we thank them.

JOAN LAUREN BRUCE HARLAN BOLL

SPECIAL THANKS
KAYE, SCHOLER, FIERMAN, HAYS & HANDLER

The Boll Family
Dana Capiello
Joanne Carson
The Day Family
JANA DESIRGH
Brooke Forsythe
Andrew Freedman
SUSAN GRODE

Valerie Harper
Goldie Hawn
Will Jennings
Lawrence Mac
David Magdael
Henry Mancini
Monica Mancini
Don May

Jade May
SANDY PRESANT
Peter Sherer
Willis Schneider
Maggie Smith
Paula Van Ness
Richard Warren
Gene Weed

Aslan House
Brooklyn AIDS Task Force
Brooklyn Pediatric Network
Caring For Babies With AIDS
Los Angeles Parents' AIDS Network

Maternal Child Immunology Clinic
Miriam Davies Children's Center
National Community AIDS Partnership
Pediatric AIDS Foundation
Pediatric AIDS Network, NY

Peer Education Programs, LA
St. Luke's-Roosevelt Hospital, NY
Tuesday's Child
Until There's A Cure Foundation

Children's AIDS Center of Children's Hospital Los Angeles

and to the families living with HIV/AIDS who allowed us to share their lives

ACKNOWLEDGMENTS

Academy Labs, Ace, Angel Acerbi, Actors Co-Op, Henry Acuna, Catlin Adams, Madeline Adams, Marlene Adler, Colby Allerton, Loni Ali, Sally Allen, Katie Anthony, Liz Applegate-Logan, Arista Records, Wendy Arnold, Paula Askansas, Nick Athis, BBC Television, Jolynn Baca, Baker/Winokur/Ryder, The Bakery Recording Studios, T.J. Baptie, Robin Baum, Maggie Begley, Melanie Behnke, Suzi Bell, Jane Beller, Bender/Goldman/Helper, Toby Berenson, Henry Bernson, Alice Billings, Howard Bingham, Elena Biosca, Jeffrey Blaine, Billy Blanks, Jr., Paul Block, Karen Borchgrevink, Bragman/Nyman/Cafarelli, Marie Brenner, Jeffrey Brian, Lynne Brickner, Rene Bracamonte, Lisa Broco, Brokaw Public Relations, Brother John, Angela Bundrant, Marian Burke, Mary Burke, Vanessa Butler, Tony Cacciotti, California Film Commission, Bruce Chapnik, John Campbell, Lisa Caputo, June Carter, Diane Castro, Century Cable Television, Ingrid Chapman, Carrie Clark, CM Color Lab, Patty Cohen, Pam Coleman, Jim Colias, Dia Collins, Todd Cooper, Sid Craig, Fernando Cubillas, Susan Cully, Gail D'Agustino, Miriam Dalgado, Amy Dane, Glenn Darby, Bill Darst, Gerald & Beatrice Davis, Carol Dean, Marilyn Delise, Sister Delores, Isabel Desanti, Misha DiBono, Dick Clark Productions, Janine Dobos, Brian Donnally, Randy Douthit, Phyllis Doyle, Stephanie Dragovich, Dubs Inc., The Dennis Dugan Family, Allen Eichorn, Steve Eng, Marty Erlichman, Henry Eshelman, Evangelicals Concerned, La Ronda Everett, Rose Fahey, Brenda Feldman Public Relations, Sheila Ferran, Gail Fetzer, Timothy & Valborg Finn, First Denver Friends Church, Julie Forsythe, Fletcher Foster, Gamma Liaison Agency, Shantel Gautier, Mary Beth Gelinas, Susan Geller, Josh Getzler, Angela Giacobbe, Chris Gibson, Tracy Gibson, Nancy Goldberg, The Gonda Family, Kelly Goodman, Greg Gorman, Dominique Graham, Jill Greenbaum, Grif Griffis, Steve & Sue Guiner, Guttman/Pam Public Relations, John Hall, Tom Hammill, Cirina Hampton, Arlene Hansen, Samantha Harper, Pam Harris, Jonni Hartman, Quay Hays, Gy Hector, Patrick Henry, James Heynen, Hiriam Hicks, Ella Hill, Paula Hinsen, Ron Holder, Allison Hollander, Donna Houston, Rosemary Hygate, John Ilvento, Insight Communications, Intermission Programs, Richard Jackson, Karen Jacobson, Robin Jamison, Christine Jardine, Michael John, Miriam Jones, Patrice Jones, Tyler Jones, Joseph, Helfond & Rix, Ilene Kadish, Father Ellwood Kaiser, Ed Kanable, Roz Karson, Bruce & Mara Kasper, John Kastelic, Aaron Katz, Judy Katz Public Relations, Sherry Kaufman, Kids Gym USA, Kira Kirstensen, Steven Klain, Linda Klass, George Kotsiopoulos, Becca Kovack, Eric Kranzler, Ray & JoErma Kreiger, Donald Kreindler, Karman Krushka, Kristi Kwon, Marisa Lackey, Jeffrey Lane, Michelle Langston, LA Party Rents, Barry Lee, Brad Lemack, Steve Liska, Phil Little, Sharon Lynn, Paige MacDonald, Mark MacIntyre, Beverly Magid, Sheri Mandel, Jan Marlin, MCA Records, James McCauley, Kathryn McEachern, Alex McElwaine, Tim Mendelson, Elliott Mintz, Missionaries of Charity, Karen Mistel, Shelly Morita, Tracey Morris, Margo Morrison, Mulryan Film & Video, James Mulryan, Richard Murphy, Susan Mustacich, NBC Studios, Tom Netterman, Michael Pace (EMA), Pacific Design Center, Maria Padula, Julia Paige, Paper Chase Printing, Paramount Hotel (NY), Paramount Studios, Sara Paris, Nicole Paskel, Paulist Productions, Carol Pearlman, Gregg Pellegrini, Sarah Pirch, Audra Platz, PMK Public Relations–East, Helga Pollack, Dr. Henry Pollack & Family, Julie Priddle, St. Clair Pugh, Quality Custom Photo Lab, Quaker Ridge Camp, Barbara Quin, Sara Recer, Bill Rich, Linda Rinaldi, Ron Rocha, Rogers/Cowan, Dusty Rogers, Steve Rosenthal, Teresa Rossomondo, Jan Rowe, Gena Rugalo, Ginny Russell, Mary Sampson, Terry Sandoval, Kevin Sasaki, Mike Sayer, Willis Schneider, Barry Selby, Scott Seoman, Jolie Shartin, Robin Shaw, Evelyn Shriver, Leslie Sloan, Susan Smella, Paul Snell, Sherry Sontag, Susan Soudrette, The Special Olympics, Spicer Papers, Andrea Stapley, Caherine St. George, St. Regis Hotel (NY), Barbara Stehr, Barry Stitch, Studio Film & Tape, Julie Sukman, Kathryn Sullivan, Laura Sullivan, Shawna Summers, Sutton, Saltzman & Schwartz, Vonny Sweeny, Vicki Taft, Alberto Talbot, Judy Thomas, Maryanne Thomas, Lisa Todd, Larry Tolin, Nadeen Torio, Beth Torroll, Travel Town/Griffith Park, Tri-Star Limousine, Cari Tucker, Pam Vaccaro, Sonny Vaccaro, John Valenzuela, David VanGilder, Juan de Villa de Moros, Cintron Vicenta, Jon Voight, Hugh Waddell, Deborah Waffer, Deborah Wald, Melissa Waters, The Weaver Family, Gere Weaver, Kameron Wells, John Wentworth, Eva Wertel, Phil & Brenda Whetzel, The White House Staff, Robert Wietrak, Randie Wilder-Pellegrini, Staci Wolfe, Shellie Yaseen, Azita Zendel
AND EVERYONE ELSE WHO HELPED US IN ANY WAY WITH THIS PROJECT

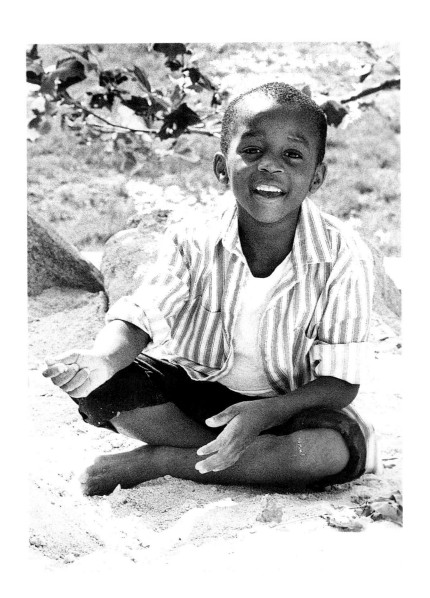

FOREWORD

All of us need to have fun, but that's not so easy when you're battling a serious disease. To a family with a sick child, doing things that other families do is a gift. You fight to maintain your hope, and feeling "normal" for brief periods of time gives you strength to go on.

When my daughter Ariel was diagnosed with AIDS she was still strong and healthy—but no camp would take her. She wanted and deserved a summer like all her friends. It was the lack of education of those around us that made her feel different.

Now in 1994 my son Jake, who is also HIV infected, has gone to many summer camps!

Today is a day we can decide to make a difference. Today is the day you can reach out to families with HIV with compassion, with understanding and with love.

The World Health Organization predicts that by the year 2000, there will be 10 million children infected with HIV worldwide. The efforts of programs such as PORTRAITS OF LIFE, With Love enable us to continue moving forward in the battle against HIV/AIDS, and give us confidence that together we can, and will, create a better future for children with HIV/AIDS and their families.

Elizabeth Glaser

Elizabeth Glaser
Co-founder, Pediatric AIDS Foundation

INTRODUCTION

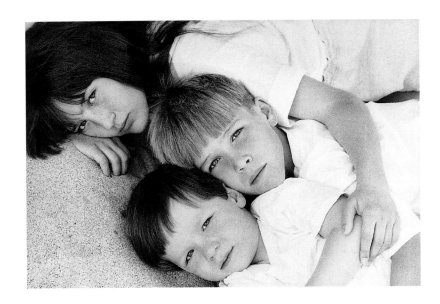

*"Do not go where the path may lead,
go instead where there is no path
and leave a trail."*
—Emerson

The loss of dignity and lives tore at the very core of my being as Ken and I traveled for two years from the east coast to the west coast, from hospital to hospital, witnessing first hand the cancer and AIDS wards. Ken was my heart, my soul. He was diagnosed with terminal cancer a few weeks after we had planned to be married. We had finally found each other, and the thought of either of us not being with the other was unbearable. We fought like warriors for Ken's survival. We were on a journey to save his life.

We lived and loved each other, holding on to each moment as long as we could. There was tremendous support and love which helped carry us through our journey of laughter and many tears. Ken was medical. I am more holistic. Together we had it all covered. Carrot juice and chemo—what a combination. However, what we didn't have covered was how tough it was to see and feel the pain of his cancer, and that of others.

But nothing touched us deeper than the horror we saw directed towards people with HIV and AIDS. I had known of the rampant fears and denials about HIV and AIDS. But when I looked around and experienced for myself the closed-minded injustices directed to all the adults, and even the children, living with HIV and AIDS, it made me feel ashamed to be a part of the human race. The blaming! We both felt that the fierce judgments and opinions about how the disease began, and what group was at fault, were stopping all of us in the world from acknowledging and ultimately accepting the emotional mountain that needed to be climbed. And in order for us as human beings to become triumphant over the fear, instead of victimized and paralyzed by the mystery, there just had to be another direction that would allow us to come together to deal with the emotions of this worldwide epidemic.

It was a cold winter's sunset outside the confines of the warm hospital room. I had been sitting with Ken since sunrise. He had been in tremendous pain and needed me to gently massage his agony away. He was scared, and I was scared with him. We knew he was dying and there was nothing we could do. I wanted to sob, but not in front of him. So I held it in and kept a stiff upper-lip, which is extremely exhausting. This day I was emotionally and physically spent. I just had to leave the room for a few minutes. I wanted to take a walk, maybe get something to drink. I leaned over and kissed him and assured him that I would be right back. His big brown eyes looked at me as if to say, "please, not too long."

I turned the corner heading towards the children's ward. A mother was pushing a cradle-on-wheels, something I had never seen before. My heart dropped because I knew a sick child was in there and at that moment I was too vulnerable to deal with an ill child. Only, the mother glanced at me in such a way that she drew me over to them. I slowly looked in the cradle to see a child who appeared near death. I felt myself about to lose it. I wanted to look away, except that this tiny, frail, little child held me captive with her eyes. This child entered my heart, and smiled at me with oceans of love and light and life. As sick and as near death as she was, she smiled. In one moment my awareness about life and death began to change.

The hospital room sparkled with decorations. It was the Christmas season. A clergyman stood by our side as we held candles and united our love before God, forever. We had come so far. What started out as a journey to save Ken's life had turned out to be a journey to find our true selves. Three weeks later, I held Ken in my arms as he passed on. I wanted to be with him. He let me. I was given a special gift. I experienced the soul of unconditional love as I swirled in the "white light"—the Universal Light and Love of God. I felt the transcending of my heart and I wanted to share this love with everyone and show how real and how powerful this love is. It was then that I promised one day to do "something," to give this love to others. What this "something" would be, I didn't have any idea.

"Do not go where the path may lead…"

After Ken passed on, it was hard to live life. Part of me was filled with intense love and joy from what I had experienced, and the other part grieved like I never knew possible. I tried to get back to my life. But that was just it—back. I could never go back. I knew I had to go forward. But at times I felt so lost. I was searching for an anchor, and I found it very close to my heart. At the age of 21, I had been given a Nikon camera as a gift. I had a natural passion for photography, and through the years I kept it as my cherished hobby as I pursued other avenues. However, it was photography that called to me as a way of expressing my feelings. So I picked up my camera and began my career as a professional photographer. I entered upon a new life filled with new dreams.

Three years ago, when the vision of the book came to me, I knew it was the "something" I had promised to do. I knew I was to do it for all of us, especially for the children—children living with HIV and AIDS. When the vision to do this photographic-essay book came to me, the path that the world was on regarding HIV/AIDS was paved with blame, fear and denial. However, I was given a clear picture that I was to focus my photographic eye on "the light and love of the soul," the energy of life. I was to bring, through photographs, the essence of all of us together and create a book that would help to gracefully broach the HIV/AIDS issues. Where families could enjoy the warm images of their favorite people together, and at the same time begin to open their hearts and minds to the very real issues of HIV/AIDS and our children. I was to head down a path that was not yet paved.

"…go instead where there is no path…"

I had already been working on *PORTRAITS OF LIFE, With Love* for two years when, on a vacation to the Big Island of Hawaii during the summer of 1993, I was compelled to visit the island of Molokai before returning home to Los Angeles and the making of this book. I was hesitant to go to Molokai because it is the island where the leper colony was located. Often, working on this book, I had thoughts about the correlation between the way people with HIV and AIDS are being treated today, and how the lepers of decades past were treated.

Even though the temperature was a scorching 90 degrees, when the plane touched down I felt a chill run through my bones. I thought, "Why am I doing this?" I was reminded of the painful times with Ken in the hospitals. I rented a car, lost my sunglasses and drove to the motel. I love to do things on my own, but I really felt strange being alone on this island. The wind was blowing hard, and there was a heaviness and emptiness all around that made me feel extremely uncomfortable. Later that day, after I had taken a swim in the pool—the ocean was too rough—I drove around the island. Molokai is a very small island, and for miles there is nothing in sight. I stopped at Father Damian's Chapel, picked a wildflower and placed it on the white fence before heading over to the area where the lepers had lived. I stood atop the mountain, the scenery was breathtakingly beautiful, but there in the wind I could feel the agony and pain of all who had been taken to live there. I felt frozen in time, and once more, I hurt from the core of my being. Part of my tears were from the sorrow of those passed souls, but mostly they were from being reminded, with an absolute certainty, not to go where this path led…the path of fear, blame and denial. I had been feeling overwhelmed by the enormity of keeping the "light" of the project safe and secure. As I stood in the bright sunshine, looking out over the crystal blue water, CREATION, I felt peace in knowing that within the darkness there is light, there is love, there is life. I smiled.

"…and leave a trail."

There is a wonderful story that I could tell about every photograph in this book. After reading these two stories, I think you will see why I chose them.

Martin Sheen held Gloria with such strength of gentleness. As I began to photograph them, I felt Gloria travel deep into my soul with her eyes. She drew me into her. Although there were several other people in the room with us, I felt as if the three of us were alone, flying together on a special level of awareness. I was swirling. When we finished, I needed to sit down. I cradled my head in my hands, savoring these moments. After a time, I looked up and saw Martin also leaning on his hand, warmed as I was. I wanted to hold Gloria. I went to her. Her little face glowing, she held out her arms as her mother handed her to me. My heart melted as she cuddled her tiny little body into my shoulder. What a treasure. What a gift. What a memory. Gloria was the second child with AIDS I had photographed, Anique Kasper was the first.

Anique was just eleven years old when she passed on. Although I only knew her for several months, she helped to show me, through her courage, the strength I would need to bring the vision of the book to the public. The first time I met Anique was at her home in Los Angeles. Lying on the sofa watching television, in a bright colorful room, her frail body was very thin and pale, but at the same time, poignantly beautiful. She radiated light. Her eyes were big and bright and alive, full of wisdom and no-nonsense. Anique was about truth and honesty. When I was around her, I felt as if I was in the presence of an angel.

Anique is the reason why I decided to photograph children with HIV and AIDS, and to include them in this book. She wanted people to know about and see the children. I had always said that I did not want to photograph HIV and AIDS children because I did not want to exploit them in any way, but it was Anique who inspired me to understand how important it is for children with HIV and AIDS to have a voice. I saw her beauty and brightness and strength. I knew she was right. I decided to photograph children with HIV/AIDS radiating the light, the love and the beauty of their spirits, rather than the sickness of their bodies. Hence, there are a few children in this book who have been diagnosed with HIV and AIDS. They are children like any other children, needing love and experiencing the joys of simply being a child.

Because of Anique, because of her love to have fun at summer camp, part of the royalties from the sale of this book will go to HIV/AIDS summer camps for children living with HIV and AIDS. The remaining royalties will go toward direct, hands on care services for children and their families living with HIV and AIDS.

Everyone who has touched this book in any way has ultimately contributed to the creation of something very unique and special. Maggie, who began this project with me, and Chase, who was there in the beginning. Sandy, Jana, Willis and Susan of Kaye, Scholer, Fierman, Hays & Handler, to whom I'm always grateful. Ken, dreams do come true. I love you. My family—my mother, Maurine, Ruth, George, Steve, Marsha, Diane, Craig. My niece, Nicole, and nephews, Stephen, Jeffrey and Kevin—my inspiration. My father, George, who passed away during the making of this book—thank you. Randie, Gregg, Don, Jade, Catherine and Jane. Rich Warren, who produced the "With Love" song for the book and the Foundation. And Bruce Harlan Boll, who has given his unconditional love, devotion and endless hours of work for over two years to the vision of this book. And God, The Power Of The Universe, whom I love and trust beyond words. Thank you for letting me be a part of it all.

I extend my warm thank you to each artist for allowing me to photograph them especially for *PORTRAITS OF LIFE, With Love*. Never before in history has such an exclusive combination of people congregated together to appear in a book for a shared passion—our children. Thank you for your help in making this book a beacon of light.

Thank you to all the families living with HIV and AIDS who stepped forward, giving us their hearts.

Let us love and embrace families living with HIV and AIDS, and let us protect all our children by educating them about HIV and AIDS, not by fear, but…with love.

Thank you to everyone.

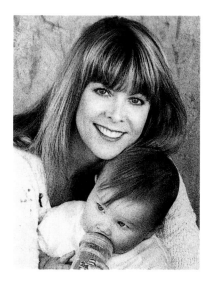

Joan Lauren
author/photographer, *PORTRAITS OF LIFE, With Love*

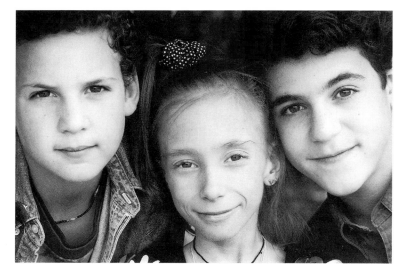

Ben Savage Anique Kasper Fred Savage

Anique Kasper
September 23, 1983 – July 1, 1992

To
children
everywhere around
the
world.

We hold

tomorrow

in our

hands

when we hold

our children

in our

arms

Barbra Streisand

+LDM

MISSIONARIES OF CHARITY
Calcutta - 700016. India.

13th Feb. 1993

Be assured of my prayers for you.
Let us continue to work, for peace
in the world — the true peace that
comes from loving and caring and from
respecting the rights of every human
being all for the Glory of God.

God Bless you

M Teresa mc

PORTRAITS OF LIFE

This beautiful baby will live
forever.
I will always
hold her
close to my heart.

—Elizabeth Taylor

Elizabeth Taylor with Elizabeth

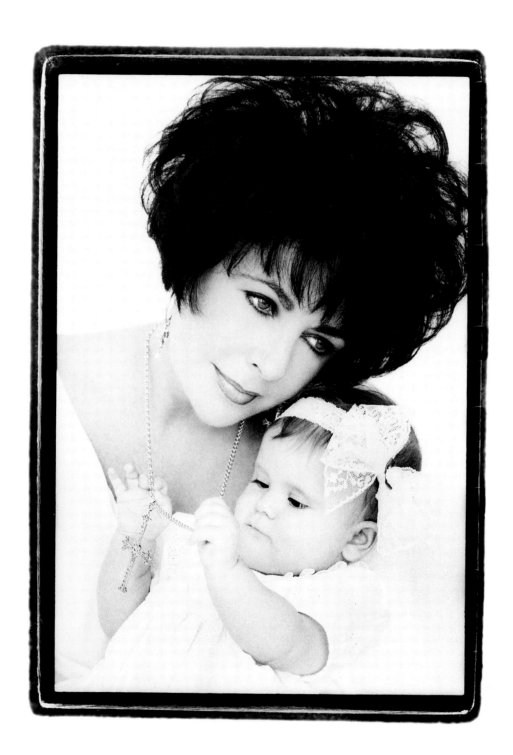

*Affirmation of life is the spiritual act
by which man ceases to live unreflectively
and begins to devote himself to his life with reverence
in order to raise it to its true value.
To affirm life is to deepen, to make more inward,
and to exalt the will to live.*

—Albert Schweitzer 1875–1965

Patrick Swayze and Lisa Niemi

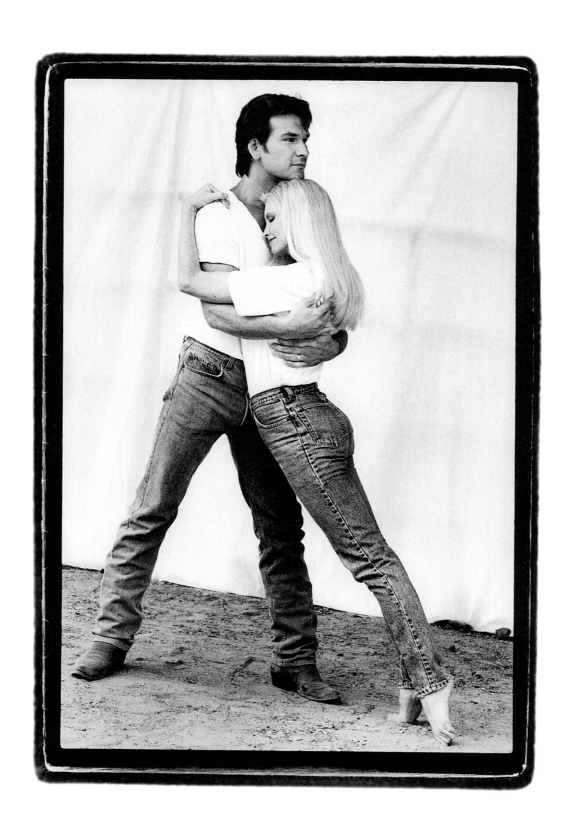

He nestled against me and smiled—
Phillip, who is twelve years old.
He was officially adopted in August 1992.
He was born HIV-positive.
Both of his stepbrothers died of AIDS.
His mother is a wonderful, loving woman.
But, Phillip has begun to have the symptoms of AIDS
and is beginning to ask his mother if he is going to die.
She tries using the Bible to comfort him,
explaining how everyone has a limited time on earth.
What breaks my heart is that Phillip has now started to be shunned by the
kids in the projects and in school.
His classmates either avoid him or try to beat him.
Phillip has lost his desire to go to school.
The same thing happens to him where he hangs out
in the projects, so he won't come out to play anymore.
His mother has taken him to a counselor.
They use art therapy,
and Phillip has been drawing pictures of himself in a coffin....
I could not hug him hard enough.

—Barbara Walters

Barbara Walters with Phillip

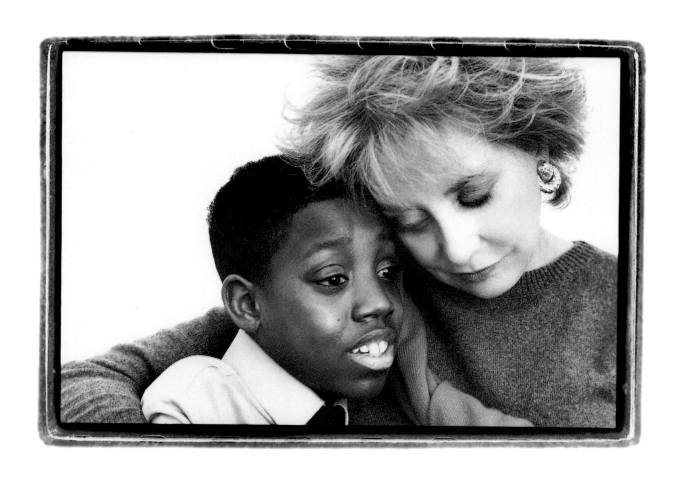

Children with AIDS are all our children.
They deserve a full future.
May we all come together
to help them
and their families.

—Maria Shriver

Maria Shriver

Children, to me,
are the window to the soul.
They are love.

—*Shanna Reed*

Shanna Reed and son Jonathan

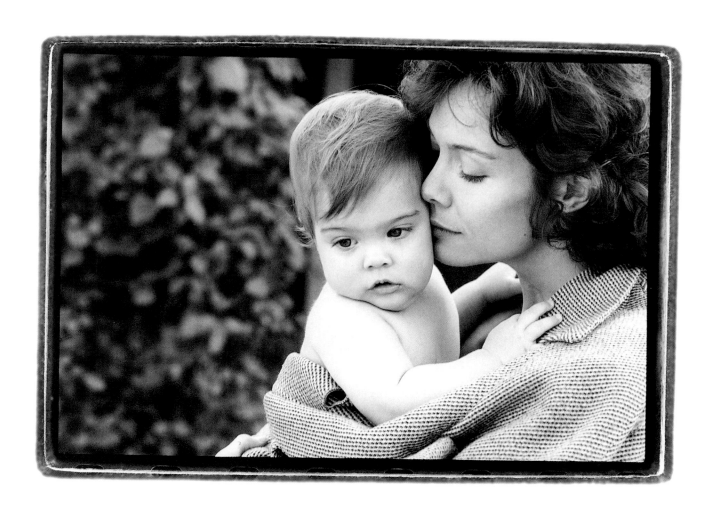

Who we are is not what we are.
Love life.... No excuses.
Peace.

—Ming-Na Wen

Ming-Na Wen and Eric Zee with Jamila

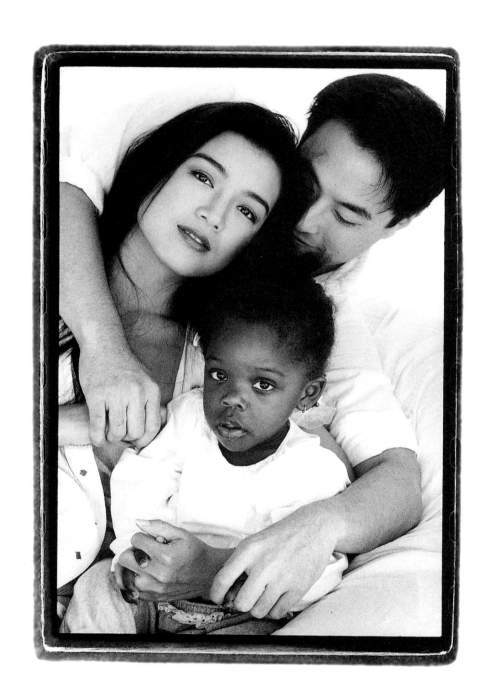

If you're looking for God
find a child...
If you can't find a child
seek the one within...
If you cannot find the child within...
Then maybe there is no God.

—Martin Sheen

Martin Sheen with Gloria

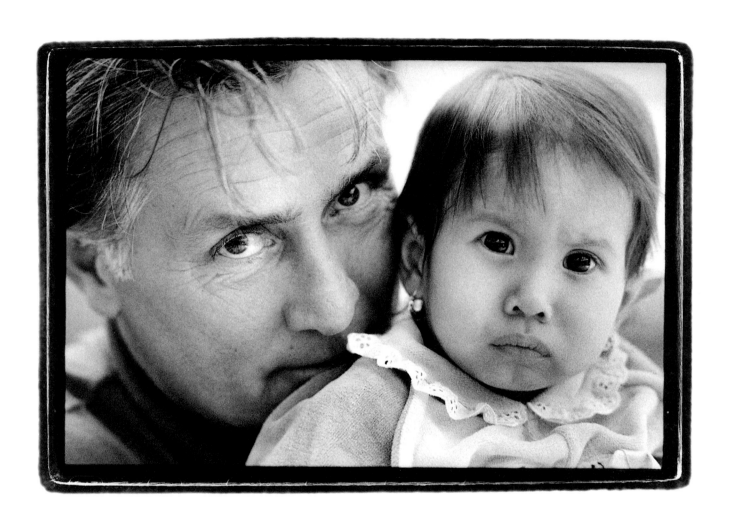

Blessed are the meek, for they shall inherit the earth.

—Sermon On The Mount, Matthew: 5

May we all find strength in our children.

—Jean-Claude Van Damme

Jean-Claude Van Damme and daughter Bianca

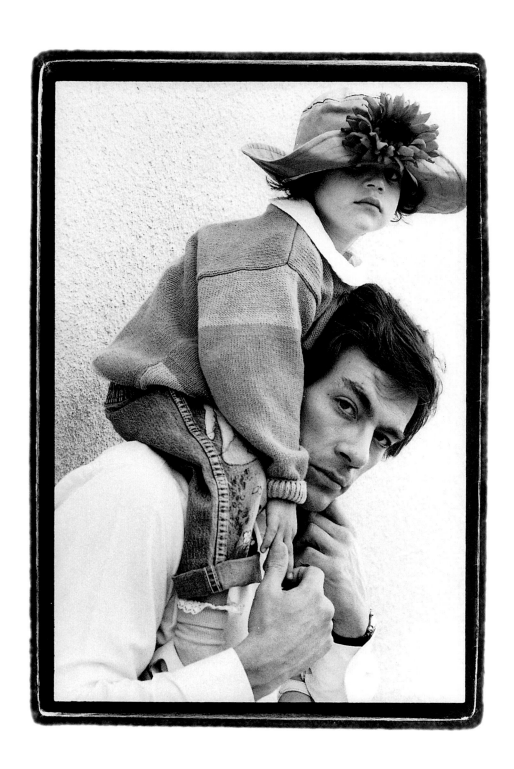

Human Beings are true family.
Their relation to one another is a divine commandment.
Love your neighbor as yourself.

—Jon Voight

Jon Voight and mother Barbara

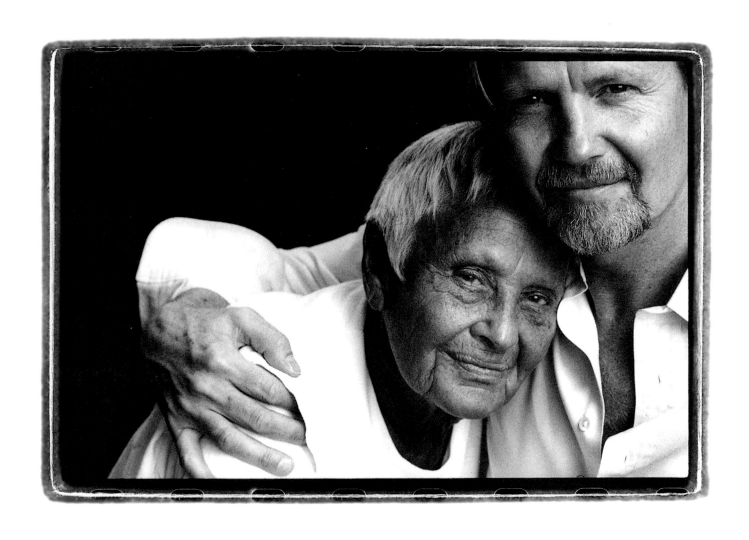

While with an eye made quiet by the power
of harmony, and the deep power of joy,
we see into the life of things.

—William Wordsworth 1770–1850

Muhammad Ali and son Asaad

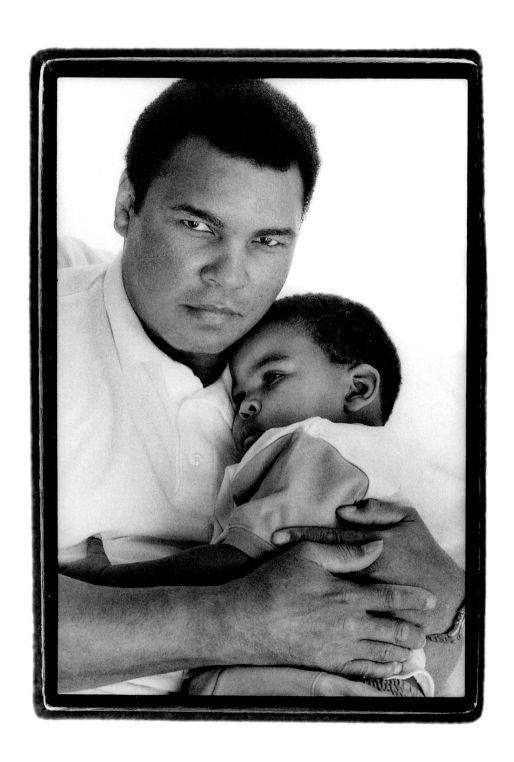

Then Jesus said unto them,
Yet a little while is the light with you,
walk while ye have the light,
lest darkness come upon you:
For he that walketh in darkness knoweth not whither he goeth.
While ye have light, believe in the light,
that ye may be the children of light.

—Jesus Christ, John 13:35–36

Whitney Houston and nephews Gary and Jonathan and nieces Blaire and Aja

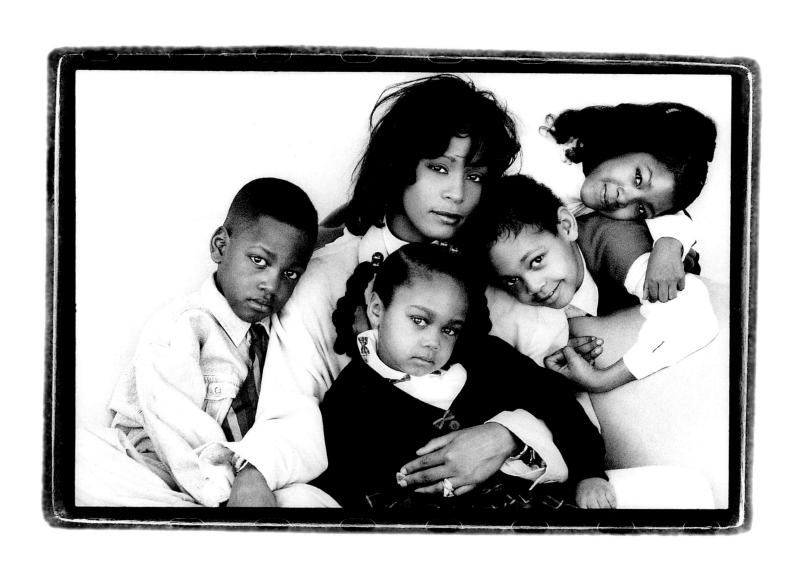

It goes without saying that our children
are our hope for a better future.
So starting from scratch we give them
the tools of what to do and not to do,
combined with the complete support of their dreams,
allowing them to build that brighter tomorrow.

—Antonio Sabato, Jr.

Antonio Sabato, Jr. and friends Tiffany and Matthew

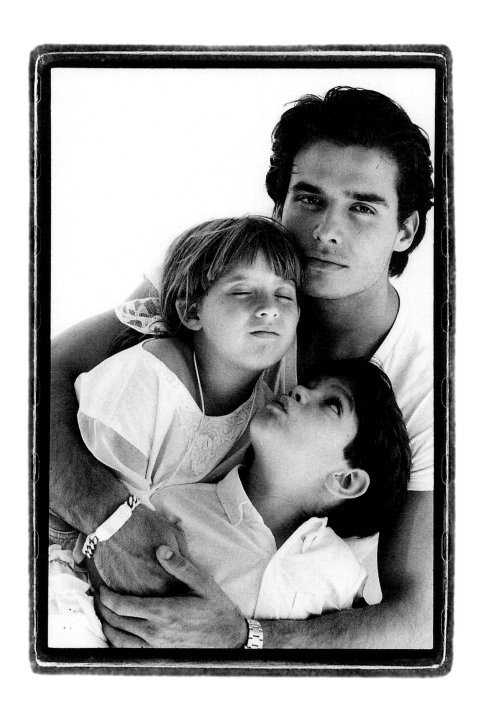

*These children
will never leave my heart.
How brave they are and how sweet.*

—*Melanie Griffith*

Melanie Griffith with Tyler, Noelle, David, Ariel and Latisha

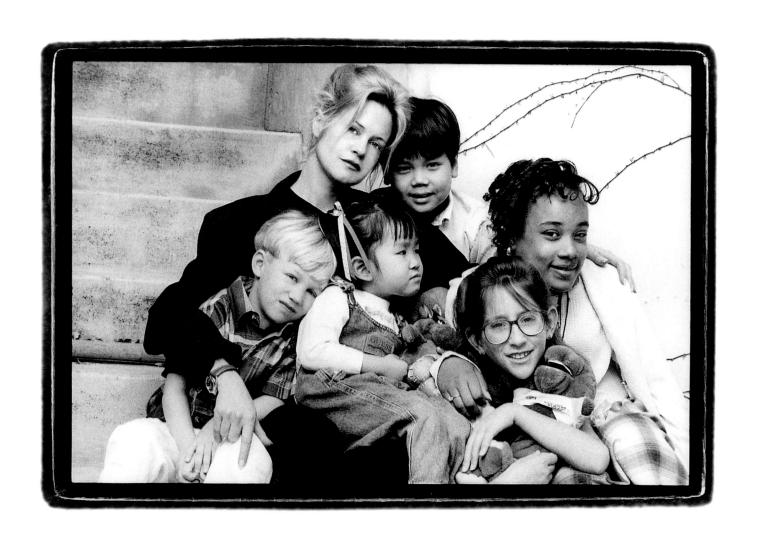

Love is patient and kind;
love is not jealous or boastful;
it is not arrogant or rude.
Love does not insist on its own way;
it is not irritable or resentful;
it does not rejoice in the right.
Love bears all things,
believes all things,
hopes all things,
endures all things.

—I Corinthians 13:4–7

Pierce Brosnan and son Sean

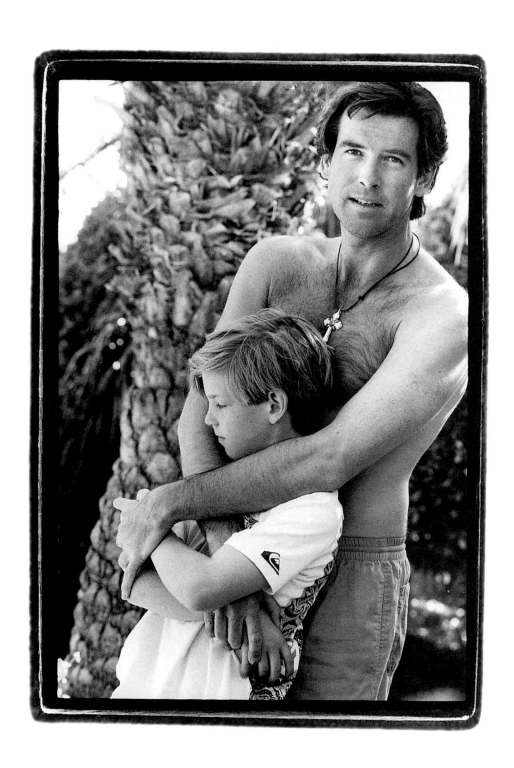

I worked very closely with Howard Ashman,
an Oscar-winning lyricist, at the twilight of his life.
While we were working together on
Disney's Beauty and the Beast,
Howard was slowly, quietly dying of AIDS.
Ironically, at the same time, I was creating life
in the form of my daughter, Keaton.

Not a day passes that I don't think of Howard.
I don't write a word that I don't consider
what Howard's opinion of it would be.
And if on a day when I'm tired or my head throbs
from thinking too much or I lose faith in myself,
I think of Howard whose life was ebbing away.
But he didn't give in.
He fought on…
pouring the last ounce of his energy and his being
into films that would be seen by children
the world over for generations to come.

Howard lifted me on the wings of his genius
and took me to places I never dared dream I could go.
For an artist, there is no greater gift.
And now I'm flying on my own and I hope I can
lift my daughter in that same way.
I hope I can show her how to soar.

—Linda Woolverton

Linda Woolverton and daughter Keaton

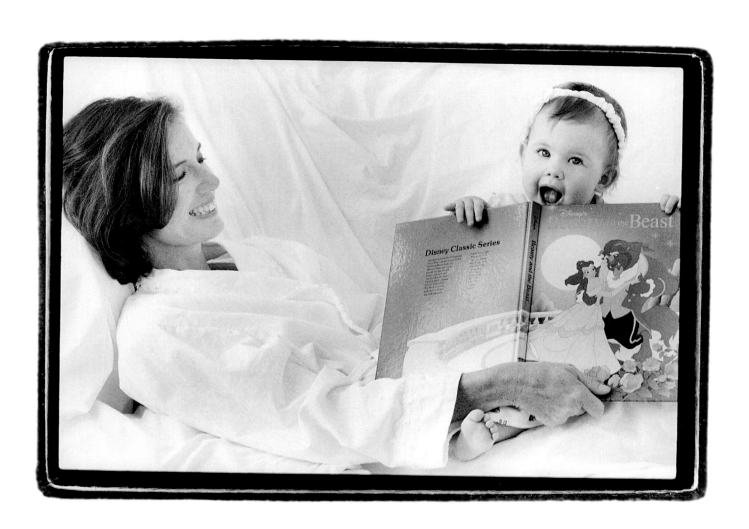

These kids—
they sure put a perspective on things,
don't they?

—Whoopi Goldberg

Whoopi Goldberg with Ty, Joshua and Nicole

The ultimate purity is a child's love.

—Carol Burnett

Carol Burnett with Tranee

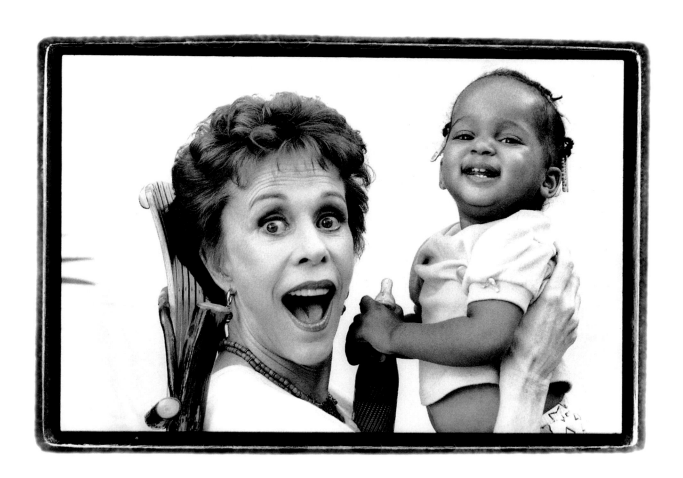

My child has always been the light of my life.
No matter what I was dealing with,
my heart would always sing
at the sound of his voice or the glimpse of his face.
Any child, anywhere, can fill me with wonder
and make me glad.
I bless all the children of the world.

—Lesley Ann Warren

Lesley Ann Warren and nieces Beth and Danielle

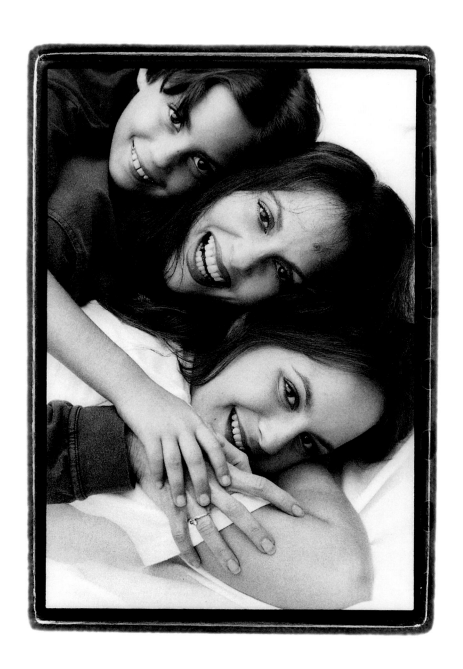

Age does not make us childish, as they say.
It only finds us true children still.

—Johann Wolfgang von Goethe, Faust 1808–1832

Shirley Jones and Marty Ingels

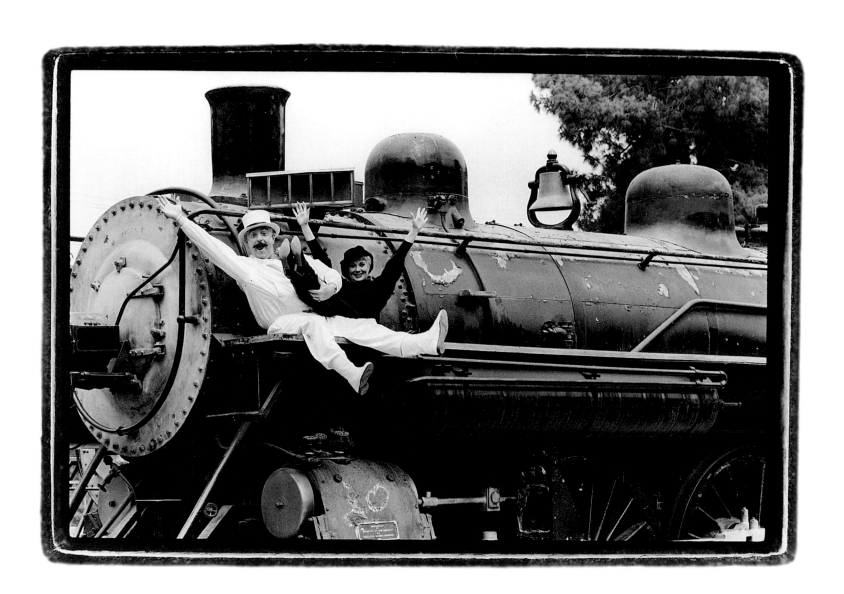

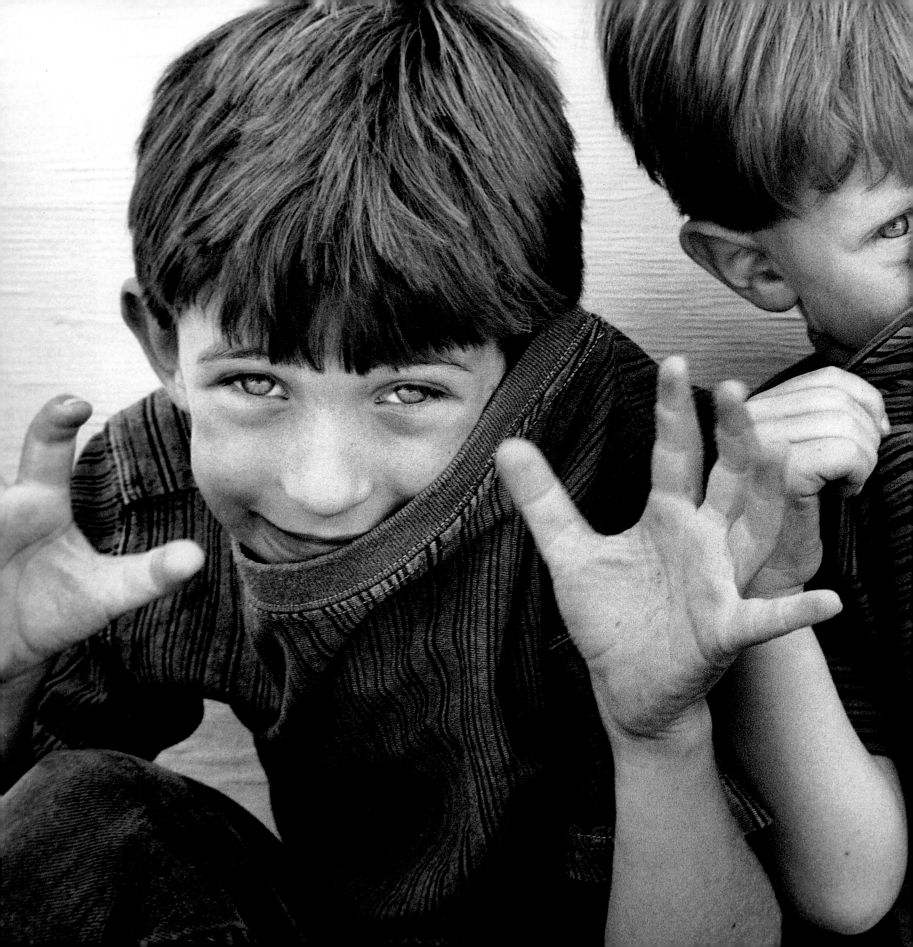

*Let children
be children.*

*A smile is the shortest distance
between people.*

—*Victor Borge*

Victor Borge and son Ron Borge

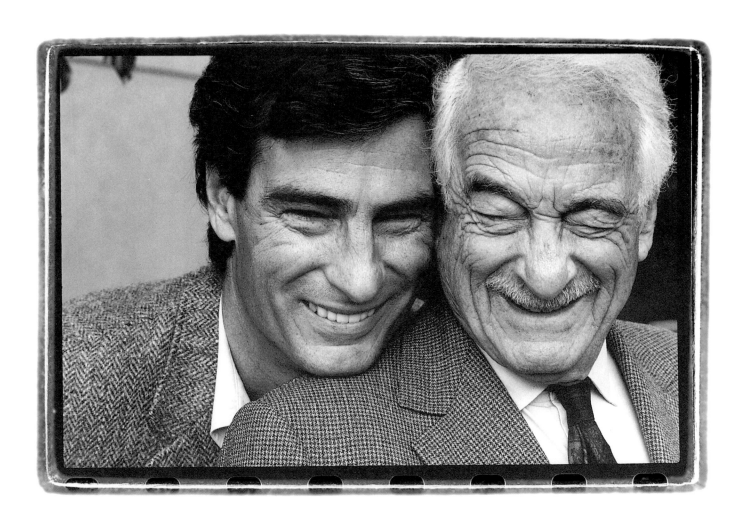

To somehow ease children in pain…
Children with no hope…
Somehow…

—Bob Saget

Bob Saget, Candace Cameron, Jodie Sweetin, Mary Kate and Ashley Olsen

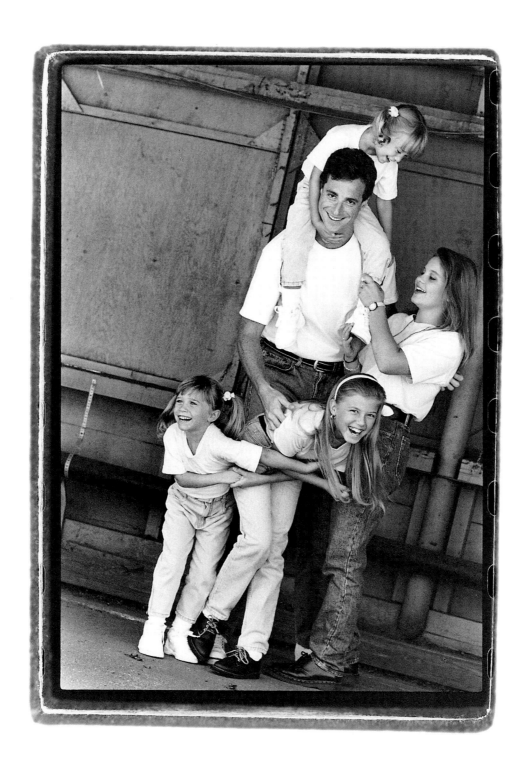

I love my friends—
warm, beautiful, funny, talented,
crazy, weepy…strong.
A wise woman once told me that,
"our strength lies in our vulnerability."
I believe that's true.

—Dinah Manoff

Dinah Manoff, Valerie Landsburg, Lisa Egan, Kathy Kurasch and Amy Schroeder

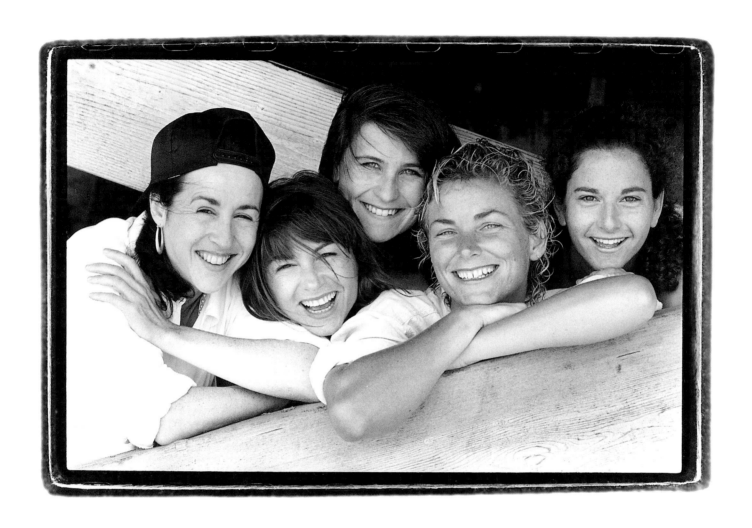

*Anything and everything
we can do to fight this disease,
we must do.
Our children's future depends on it.*

—Gregory Hines

Gregory Hines and father Maurice Hines

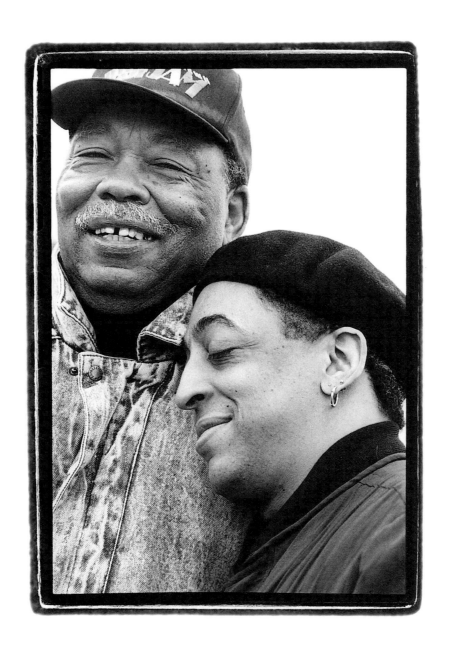

*Life
and Love
is
Chaia.*

—*Larry King*

Larry King and daughter Chaia

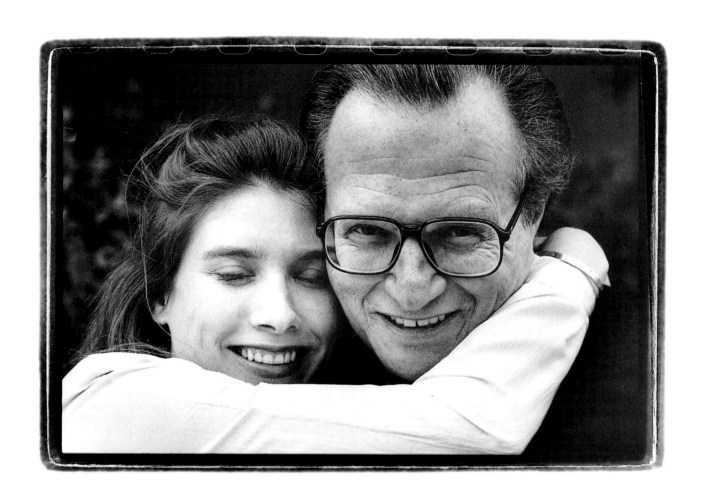

All kids are our kids.
Giving protection and comfort
to other people's children
is not an act of charity.
It's an opportunity to enrich the future.

—Shari Lewis

Shari Lewis and Lamb Chop with Cory

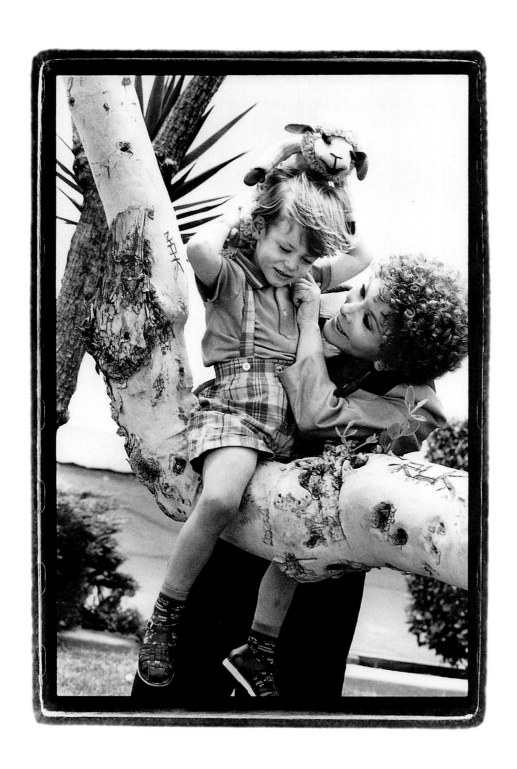

*How much more nicely we think of ourselves
when we discover our capacity
to make human jewels.*

—*Edward Asner*

Edward Asner and his children Matthew, Kate and Charles

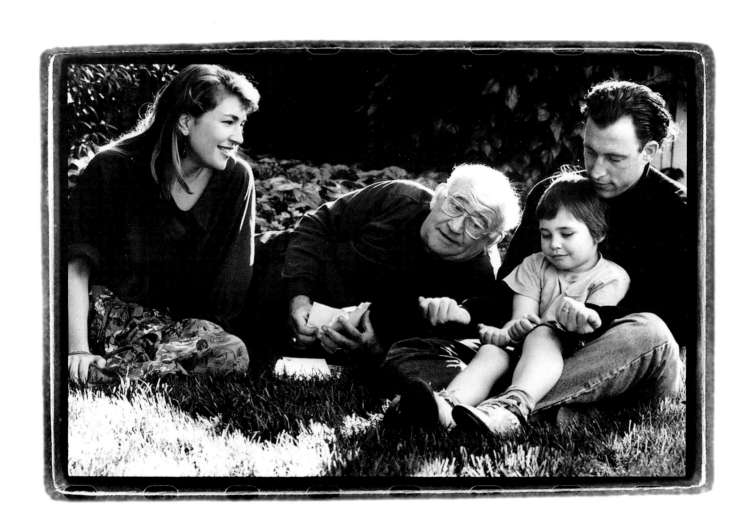

The Earth Tribe

The earth tribe is a rainbow
Made of many shades
Our kingdom is called beauty
By those who understand

Our mother earth she is sacred
And therefore we are too
We are nurtured in her womb
And thankful to be fed

Bright beautiful children
All created just to shine
As I look around me
Many colors to be found
If I look inside of me
And also see my light
Feel my light

With your light
And mine together
Let's commence
Our sacred flight
Let's go searching
Through the darkness
For those lights
I know exist

In all colors of the rainbow
There's beauty, there's knowledge
To be shared
In this way
We are all one

—Selim Running Bear Sandoval

Lindsay Wagner and friends Selim and Gail

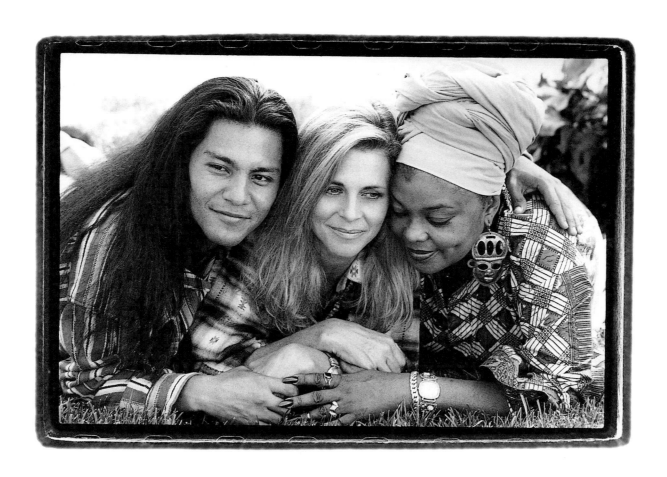

Look to your health;
and if you have it, praise God,
for health is the second blessing
that we mortals are capable of;
a blessing that money cannot buy.

—Izaak Walton 1593–1683

Kareem Abdul-Jabbar and sons Kareem and Amir

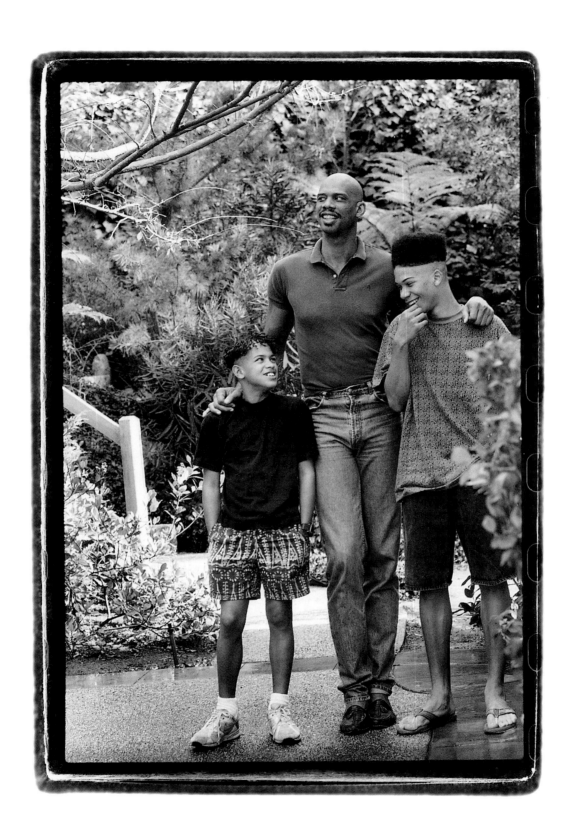

Every individual matters,
human and non-human alike.
Every individual can make a difference.
Together, if we care,
we can heal the world.

—*Jane Goodall*

Jane Goodall and John and Michael

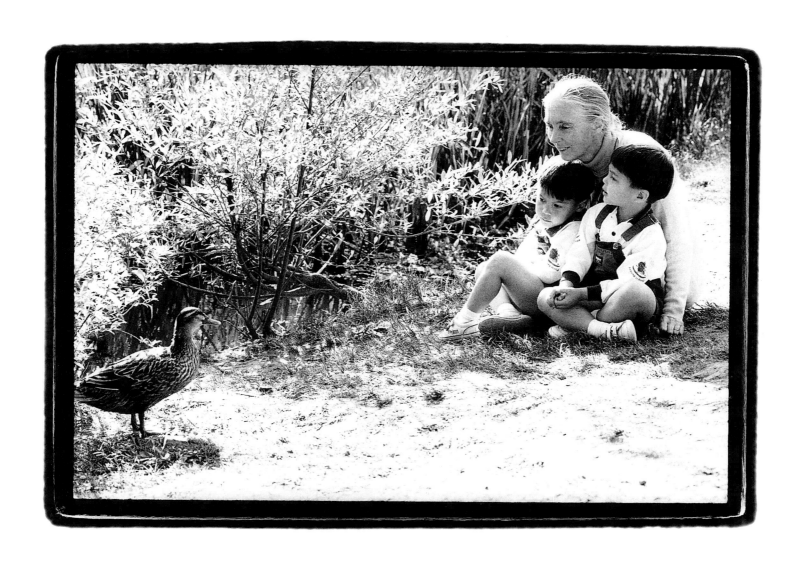

It's not how long we live, but how we live.

—Beatrice Wood

Beatrice Wood and friends Dylan, Cody and Max

The single element of life
with the most potential
for real, lasting joy
on an hour-to-hour basis is children....
I've had a very full life with lots of ups and downs,
but probably the most consistent joy in my life
has been parenthood....
If you look real hard you can see yourself as you are:
coming back at you in a child's eyes!

—Connie Stevens

Connie Stevens with Rayana

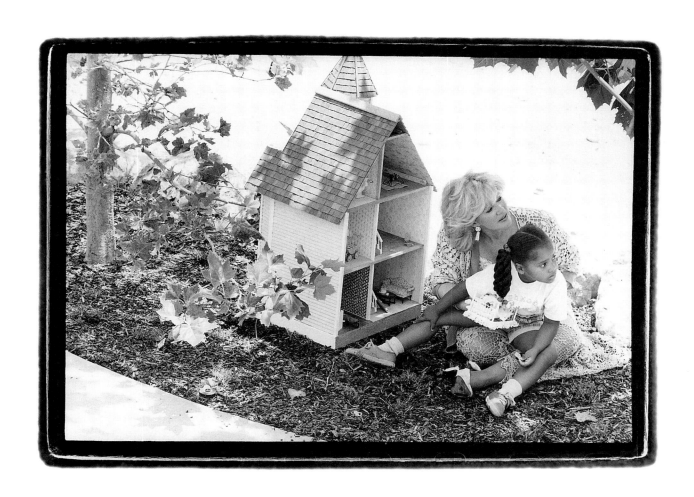

There is no deeper love we feel, even a romantic love,
than the love we feel for children.
Anyone incapable of responding to their innocence
and dependency with anything less than love
is beyond my comprehension.

—Ian Ziering

Ian Ziering and Coty

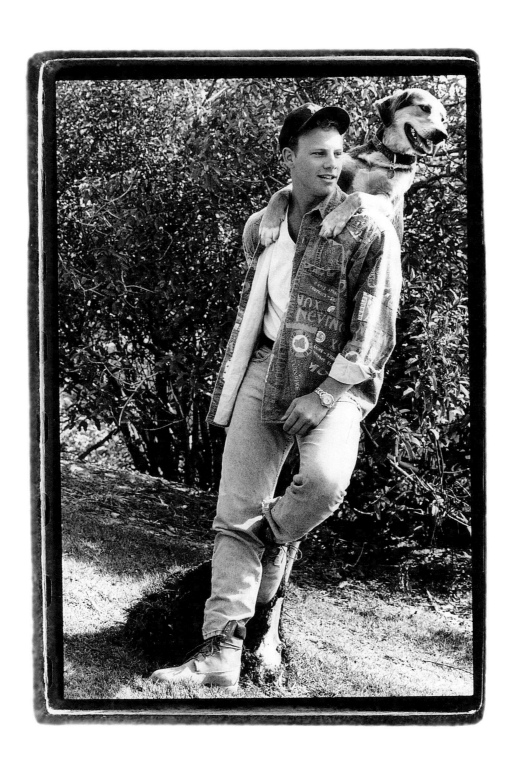

Children remind us every day
that compassion
is the ultimate ethic.

—Casey Kasem

Casey and Jean Kasem and daughter Liberty

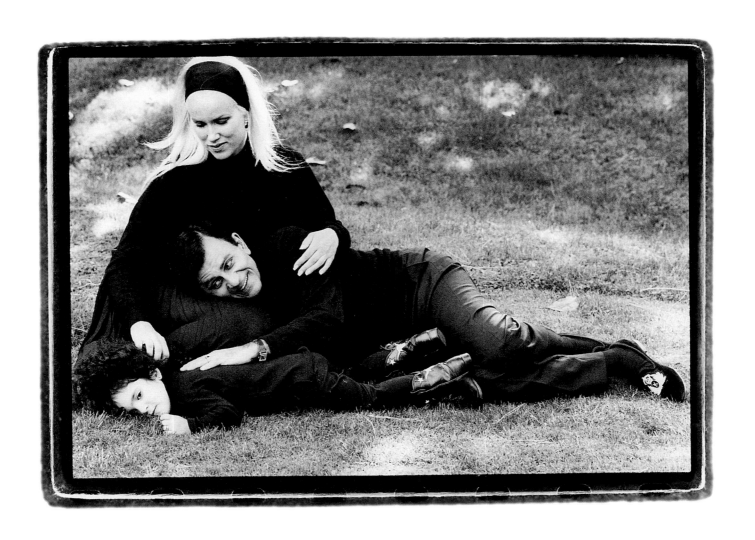

If we as a civilization have ever had the need
to hold God's unchanging hand…
it's now.
Let us pray!

—*Arsenio Hall*

Arsenio Hall with James

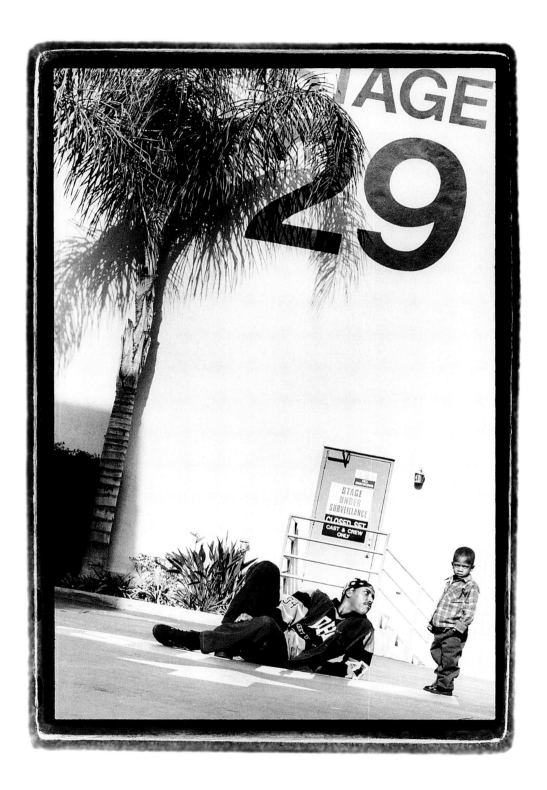

*AIDS doesn't care how
old you are.
AIDS doesn't care if
you're male or female.
AIDS only wants to kill.
Let's all work together
to stop this murderer.*

—Johnny Cash

Johnny Cash with Michael

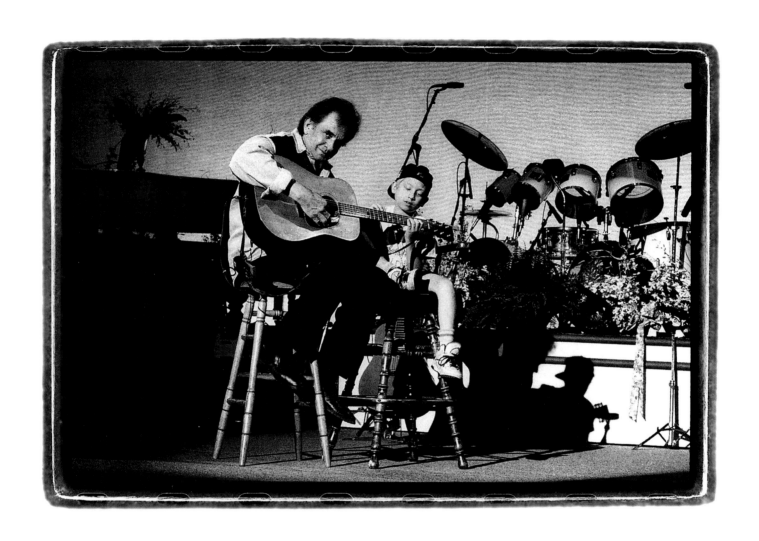

The worst sin towards our fellow creatures
is not to hate them,
but to be indifferent to them:
That's the essence of inhumanity.

—*George Bernard Shaw 1856–1950*

Malcolm-Jamal Warner and Michelle Thomas

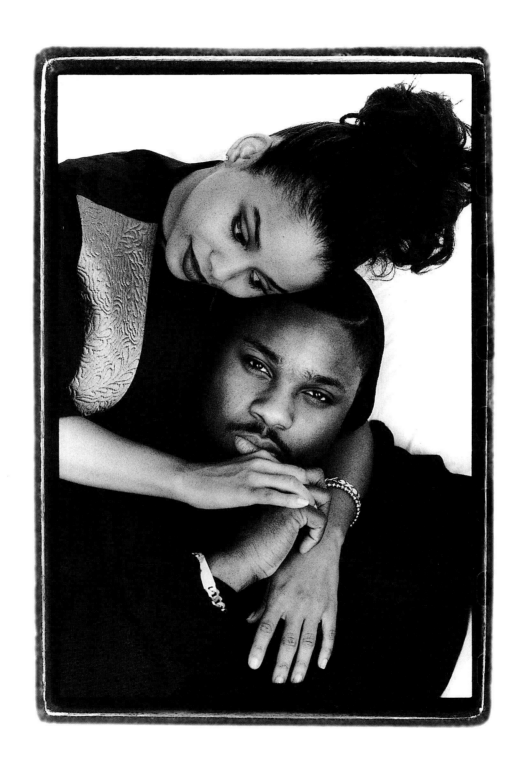

Words are not enough….

—Edward Furlong

Edward Furlong with Isabella

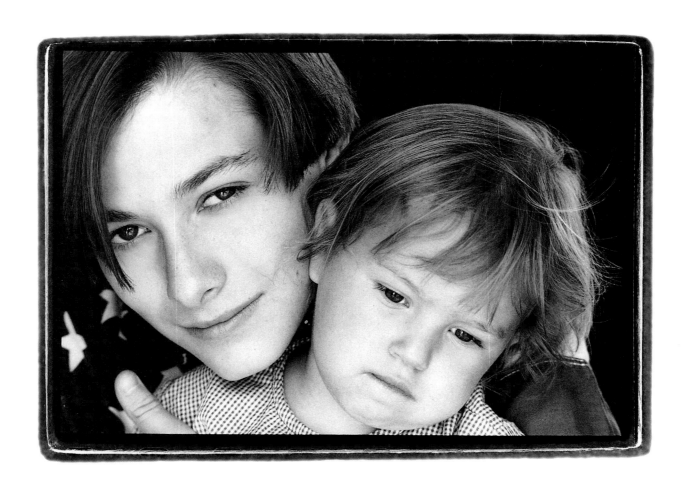

Children symbolize the miracle
of creation
and the ultimate hope
for tomorrow.

—Donna Karan

Donna Karan and daughter Gabrielle

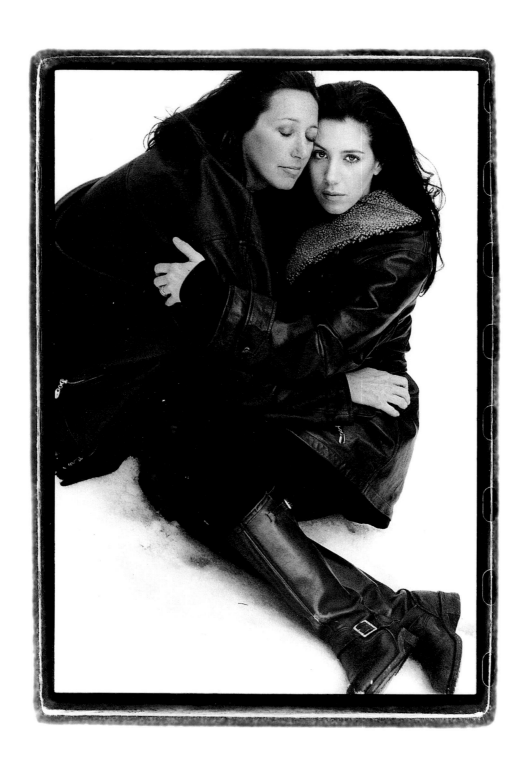

I'm eighteen now, but my little brothers
are just three and six years old.
I think about how devastated I'd be
if anything bad ever happened to them—
and about how their childhood innocence
will surely be affected by the reality of AIDS.
Somewhere, everybody has a little brother or sister.

—Jeremy Miller

Jeremy Miller and brother Adam Levine

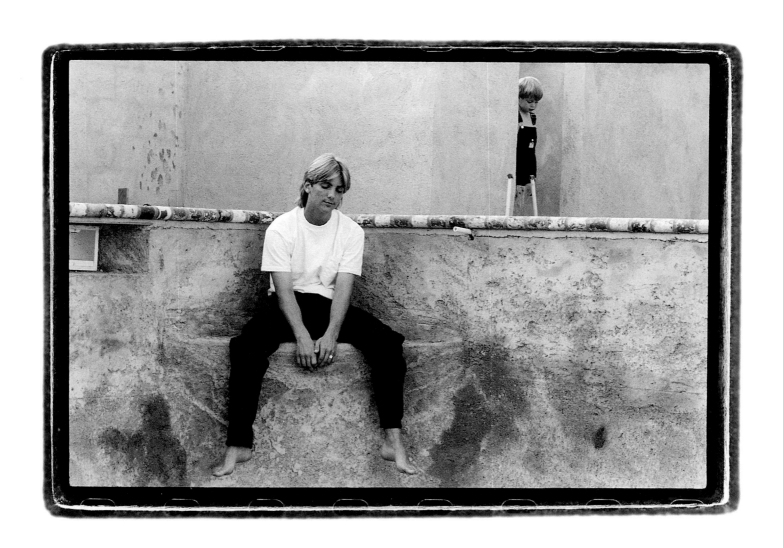

Music has the power to lift the human spirit
out of its physical immediacy, and
to deliver that spirit away from the fear of pain…
sometimes for a moment, or sometimes for a lifetime;
its substance can fill the emptiness of despondency;
its language can reconcile the confusion of suffering.
And music can create a smile,
even when ideas and philosophies fail.
What a gift….What a responsibility!

—Roy Tanabe

Members of the Los Angeles Philharmonic:

Barry Gold, Cello

Christopher Hanulik, Principal Bass

Roy Tanabe, Violin

Boyde Hood, Trumpet

Janet Ferguson, Principal Flute

Dale Silverman, Associate Principal Violin

David Weiss, Principal Oboe

with Luis, Gustavo, Micky and Jonathan

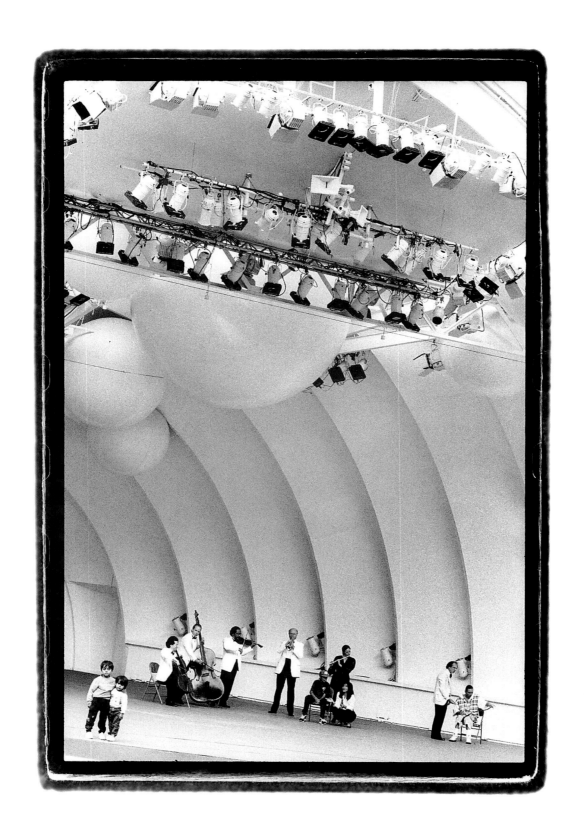

When you find love, cherish it....
Hold it dear....
It is a gift from God.

—Susan and Jeff Lester

Susan Anton Lester and Jeff Lester

*Children
should be allowed
to dream
their own dreams.*

Gazing in children's eyes
I catch glimpses of the morrows to come.
And when a child's love makes its way
to the center of my heart,
I am held by the wonders
of that which is sacred and eternal.

—France Nuyen

France Nuyen with Jessica

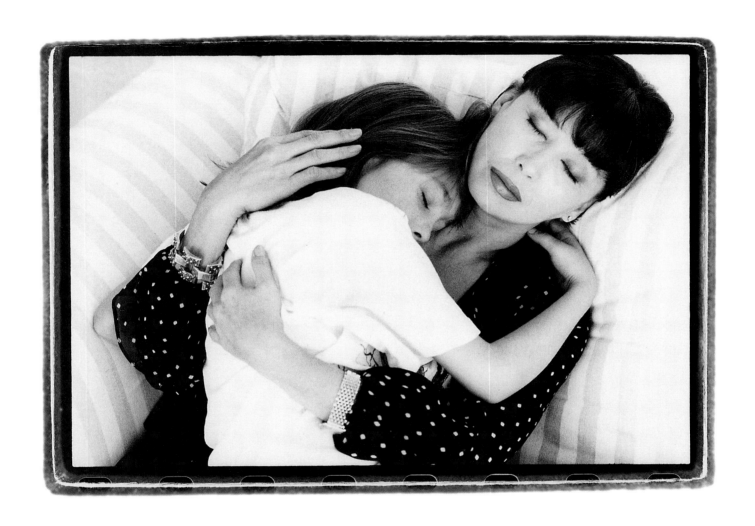

Our time, our understanding, and our hearts
are essential in the fight against AIDS.
A cure is a moment away.

—Kellie Martin

Kellie Martin, sister Heather and mother Debbie

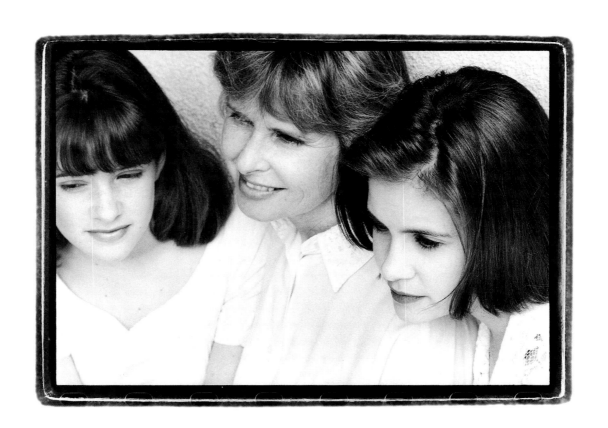

There's no time to kill between the cradle and the grave.
Father Time still takes a toll on every minute that you save.
And legal tender's never gonna change the number on your days.
The highest cost of living's dying, and that's one everybody pays.
So, have it spent before you get the bill,
there's no time to kill.
And if you don't look ahead, nobody will,
there's no time to kill.

—Clint Black

Clint Black and Lisa Hartman Black

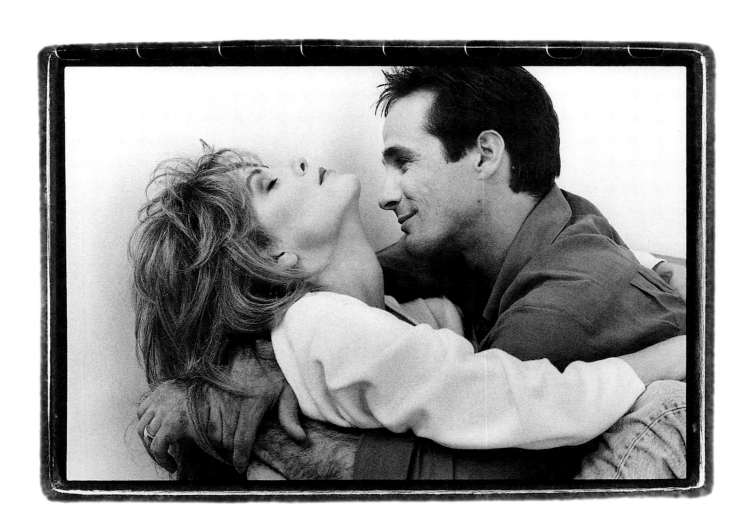

It is not enough merely to exist....
Every man has to seek in his own way
to realize his true worth.
You must give some time to your fellow man.
Even if it's a little thing,
do something for which you get not pay
but the privilege of doing it.
For remember,
you don't live in a world all your own.
Your brothers are here too.

—Albert Schweitzer 1875–1968

Marilu Henner and goddaughters Gabriella, Taylor, Isabella and Olivia

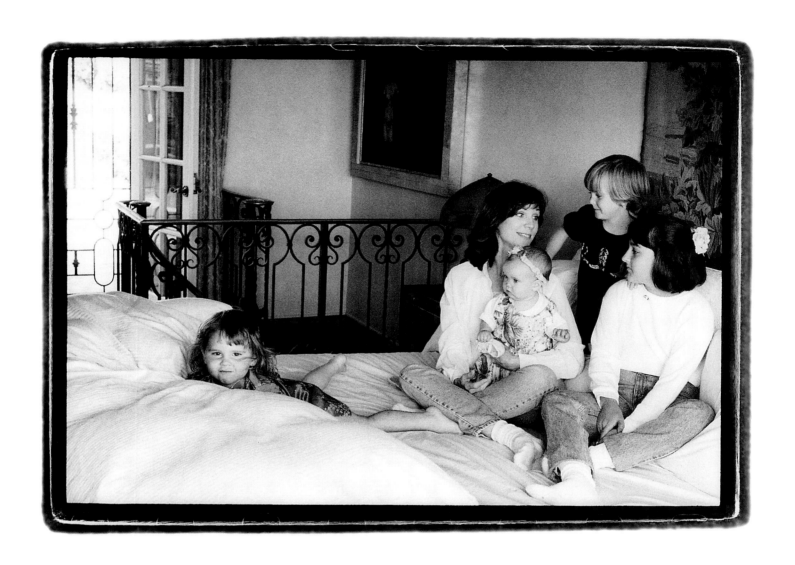

It's not just that we need to talk to our children more,
it's that we need to listen and allow them to really be heard,
to really be heard,
to really truly be heard.
Listen to the little ones.
"Out of the mouths of babes."

—*Valerie Harper Cacciotti*

Valerie Harper Cacciotti and daughter Cristina Harper Cacciotti

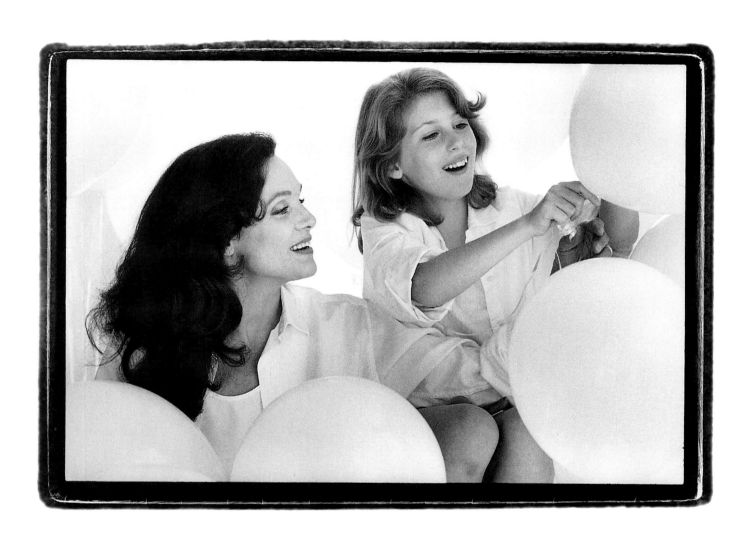

I believe in the end the truth will conquer.

—*John Wycliffe, c. 1330–1384*

Dikembe Mutombo and children in Phoenix, Arizona

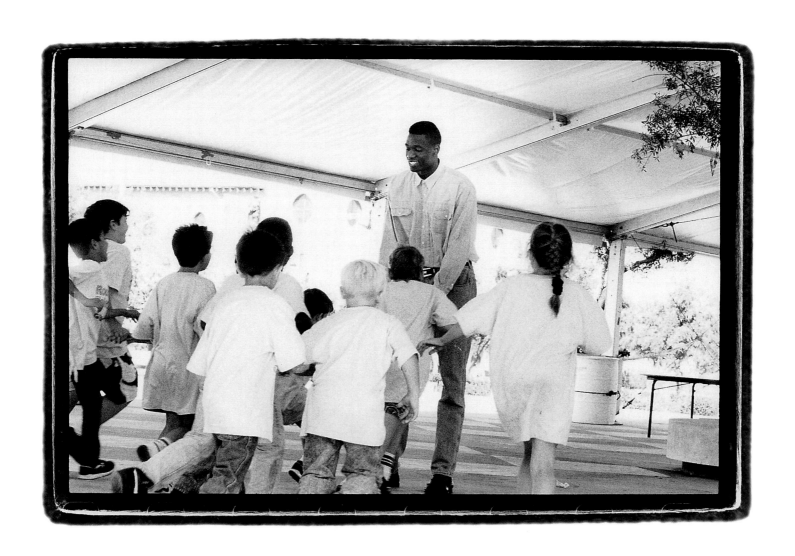

Timeless situation
Nature regeneration
Life continuation

—Ellis Hall, submitted by Jayne Kennedy Overton

Jayne Kennedy Overton and Bill Overton, Cheyenne, Savannah and Kopper

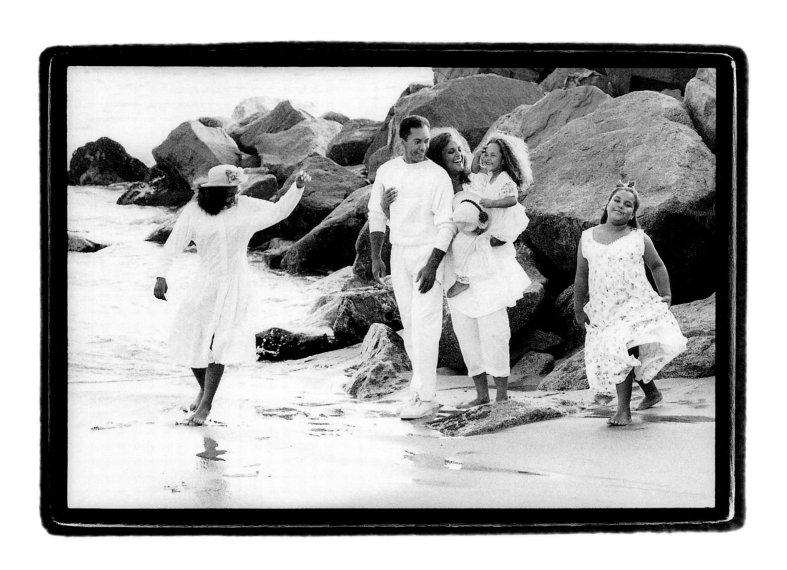

Children are our greatest treasure.
They are the center of our lives,
our anchor, our overriding priority.
And yet, children are more than poetic metaphors
for hope in the future.
They are the real, practical investment in
the further development of the species.
In them, we celebrate life, continuity,
all the possibilities
and potential of our four million years of evolution.
Those born into the plague of AIDS
are special messengers,
confronting unique and difficult challenges
with courage and dignity.
We must watch and listen closely,
for they elevate us all to a higher level of
compassion and understanding.
Through our love, we arrive at
a new sense of what it means to belong.

—Jean-Michel Cousteau

Jean-Michel Cousteau and Becky, John, Daniel, Anthony, Meredith,
Tegan, Grace, Christine, Misha and Cleya

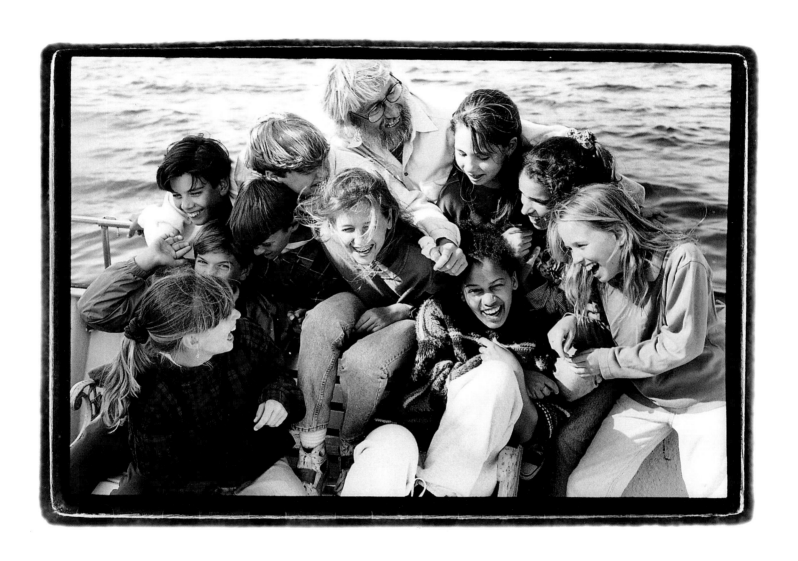

Let knowledge grow from more to more,
but more of reverence in us dwell;
that mind and soul, according well,
may make one music as before.

—Alfred Lord Tennyson 1809–1892

Corbin Bernsen, Amanda Pays and their sons Oliver, Henry and Angus

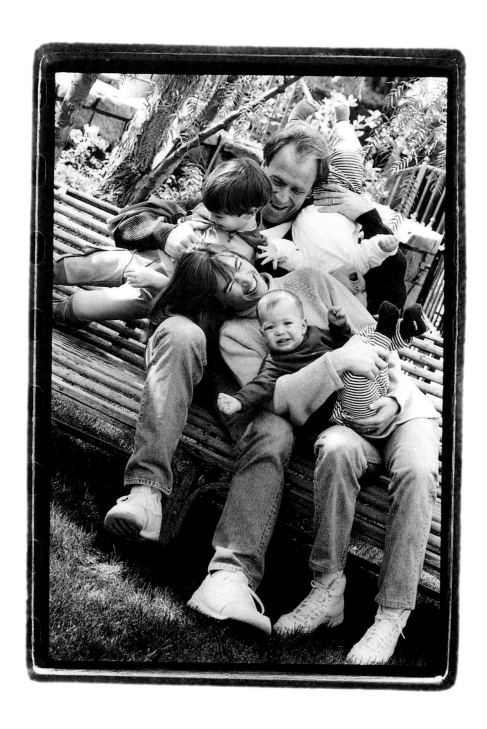

Those who give you love are those you cherish.
With children and animals,
their love is fulfilling
and generously given without condition.
May we learn from them.

—*Dick Clark*

Dick Clark and Molly, Maybeline, Lucille and Bernardo

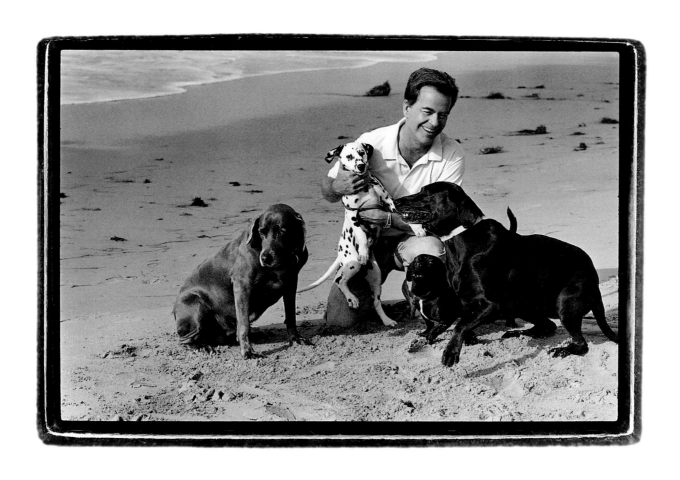

Mama look at me
Mama looked at me
And now I have eyes to see.

—*Thornton Wilder,* Our Town

Cloris Leachman, granddaughters Skye and Ariel and her little dogs Bill and Jo

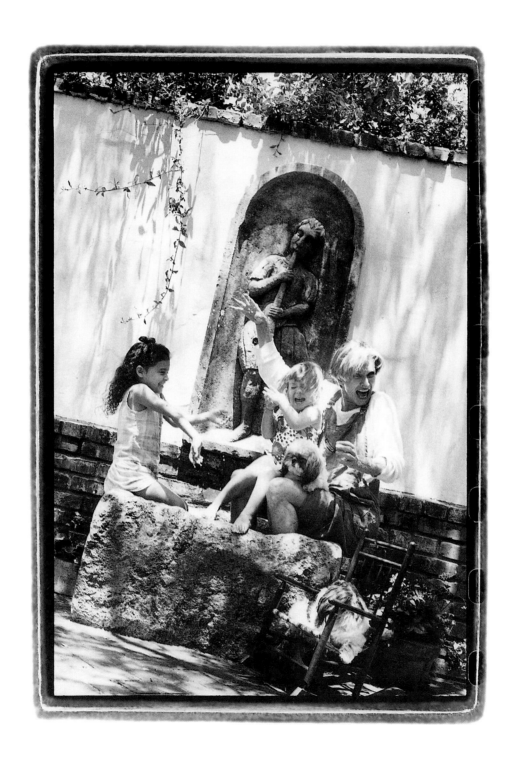

Joy
is God's way of telling us
we are on the right path;
sustained joy
requires the elimination of others' suffering.

—Judith Light

Judith Light, Robert Desiderio, Herb Hamsher and Jonathan Stoller

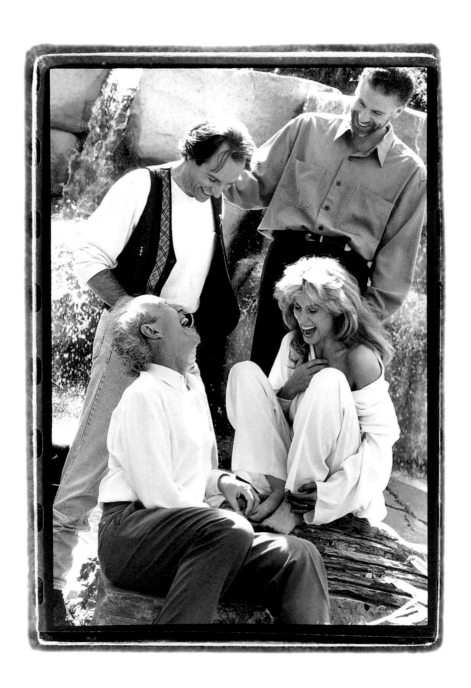

*The measure of our humanity
is our willingness to take care of the children,
for they are God's gift to the world.
May they always know the gentle closeness of a lullaby
and our love.*

—Linda Evans and Yanni

Linda Evans and Yanni with Joey and Lauren

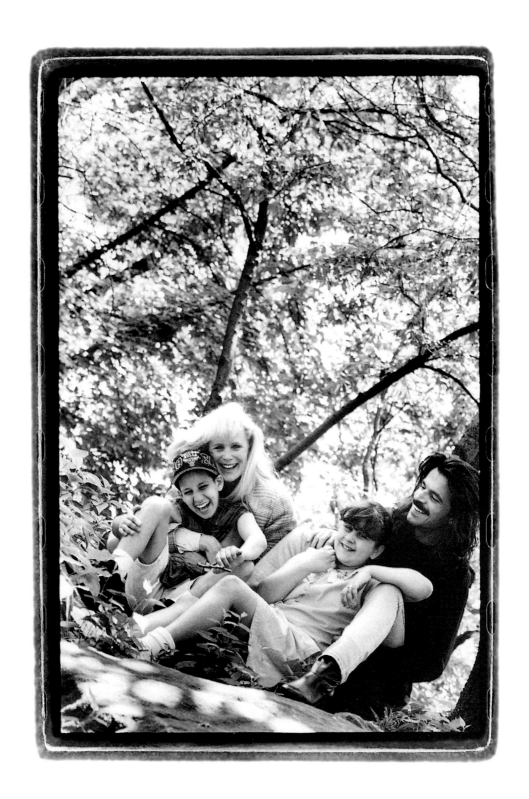

*In light of life's challenges, we
have an incredible opportunity
to discover within ourselves
tremendous strength and courage
that in simpler times might not have been realized.*

—Deborah and Mitch Gaylord

Deborah, pregnant with Kevin Tyler, and Mitch Gaylord

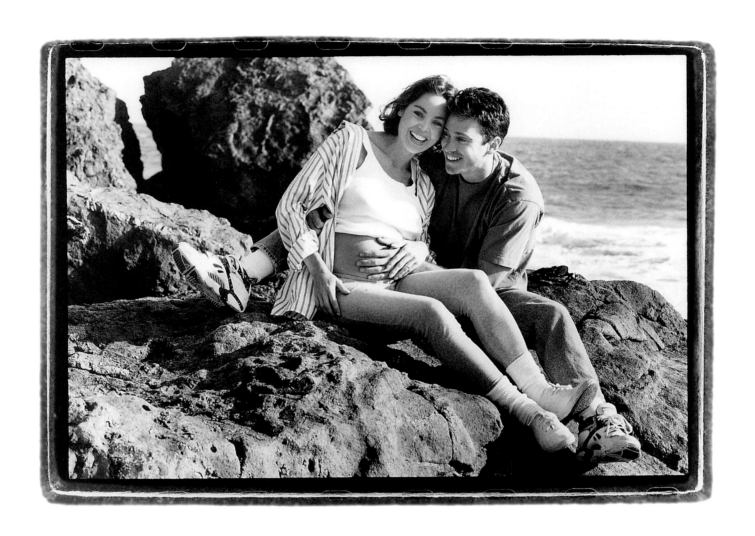

You are a child of the universe,
no less than the trees and the stars;
you have a right to be here.
And whether or not it is clear to you,
no doubt the universe is unfolding as it should.
Therefore be at peace with God,
whatever you conceive Him to be,
and whatever your labors and aspirations,
in the noisy confusion of life keep peace with your soul.
With all its sham, drudgery and broken dreams,
it is still a beautiful world.
Be cheerful. Strive to be happy.

—Desiderata, *origin unknown, submitted by Oliver Stone*

Oliver Stone and Elizabeth Stone and sons Sean and Michael

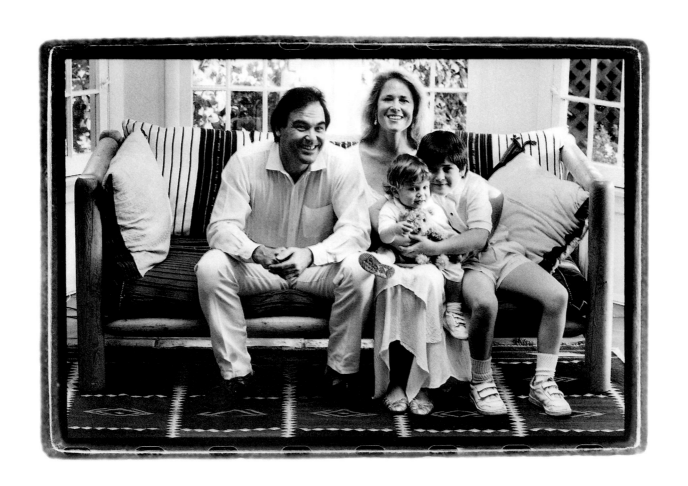

*What is a greater blessing in this life
than a big family reunion,
with love,
laughter and memories?*

—*Dale Evans*

Roy Rogers, Dale Evans and family

As you treasure those you love…
do not want,
but give, love.

—*Ronnie and Karen Lott*

Ronnie, Karen, Hailey and Isaiah Lott

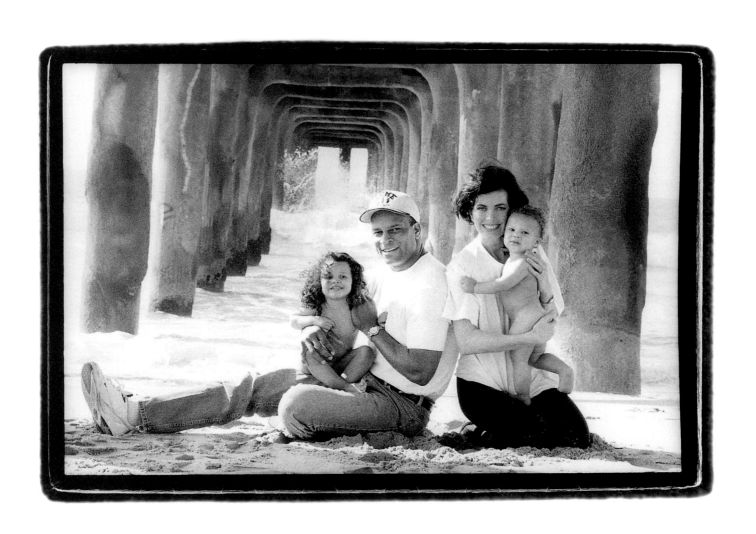

*By the year 2000, over ten million children worldwide
will be infected with the HIV/AIDS virus—
Please help give our children a future.
Join the fight against HIV/AIDS
and prevent this prediction from becoming a reality.*

—Mary Jo Slater

Slater-Taron Family

Ryan, Emily, Chan, Christian, Mary Jo, Josh, Karma and William

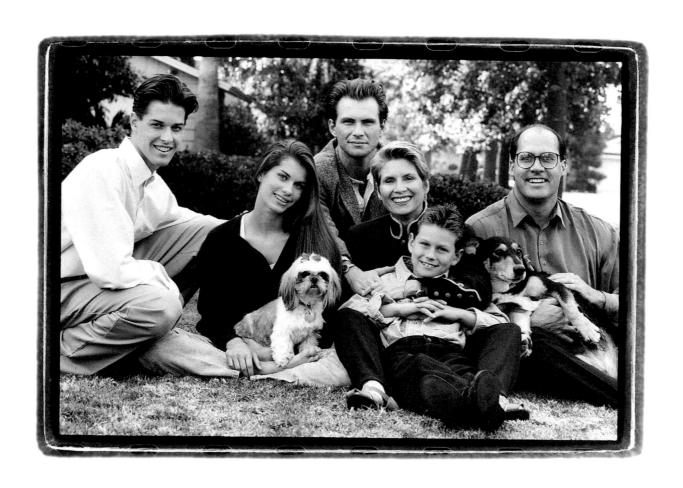

The incredible courage we see daily
in our families with HIV
gives us the strength, determination
and hope to find a cure.

—Dr. Yvonne Bryson

Dr. Yvonne Bryson and sons Bryson and Ryan

In the darkest of times, we all need love.

—*Nikki Sixx*

Nikki Sixx and son Gunner

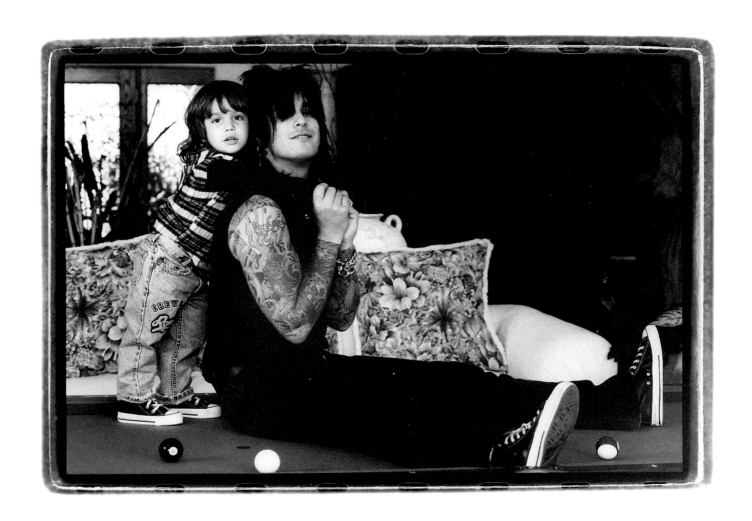

What we need right now
is more
LOVE
in the world.

—Michael Feinstein

Michael Feinstein and Bing Clawsby

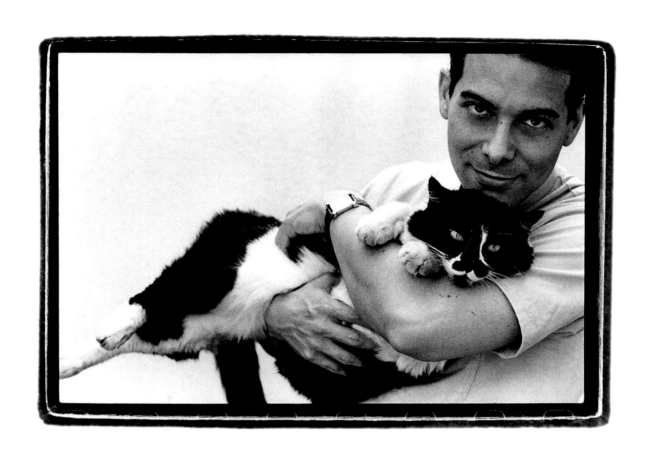

Protection is the priority.

—*TLC*

TLC: T-Boz, Left Eye and Chili

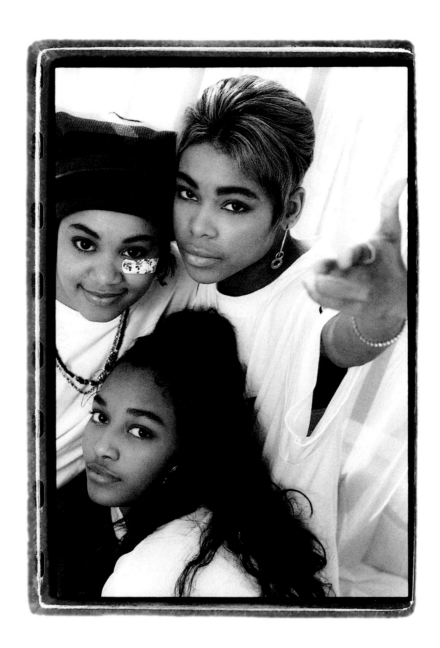

Artists are the creators.
We have lost so many talented creators,
but through
Love and Friendship
we will pass on the torch of creativity
to the children
of a new generation.

—Estelle Getty and J. David Krassner

Estelle Getty and J. David Krassner

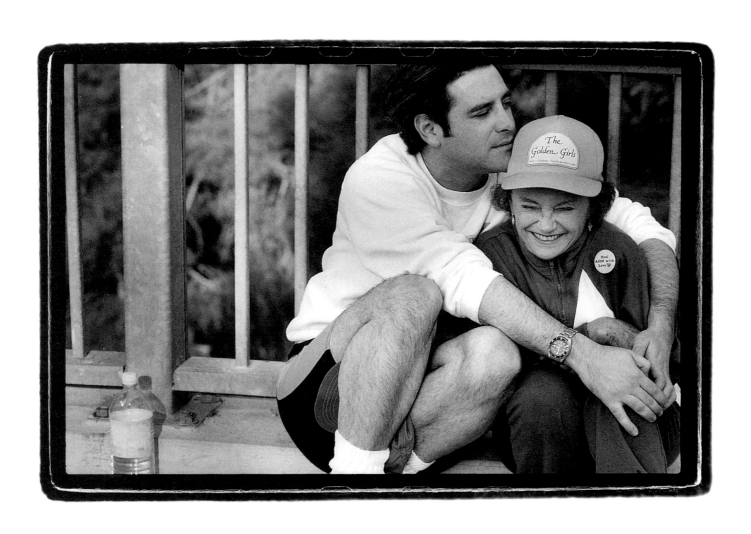

My six children are the "constant" in my life.
But then, so are my six grandchildren!
As I sing in one of my songs,
for my children and grandchildren,
"The Price of Real Love is NO CHARGE!"

—*Tammy Wynette*

Tammy Wynette and granddaughters Natalie, Sophia, Christina and Catherine

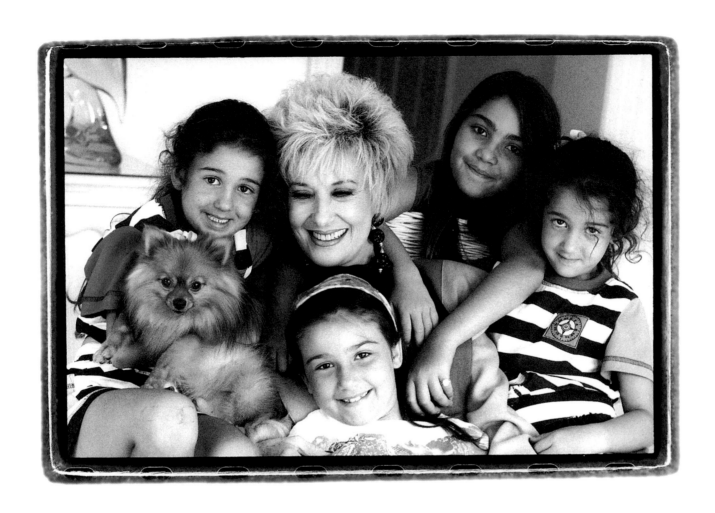

How many must die before we fight for their lives?
Celebrate living by caring.

—Gabrielle Carteris

Gabrielle Carteris with Leonard

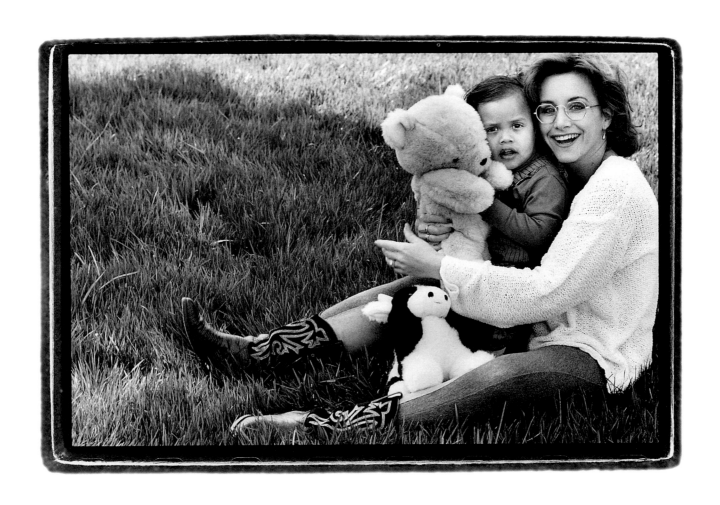

Love kindled by virtue always kindles another,
provided that its flame appears outwardly.

—Dante Alighieri 1265–1321

Marian and Chuck Jones

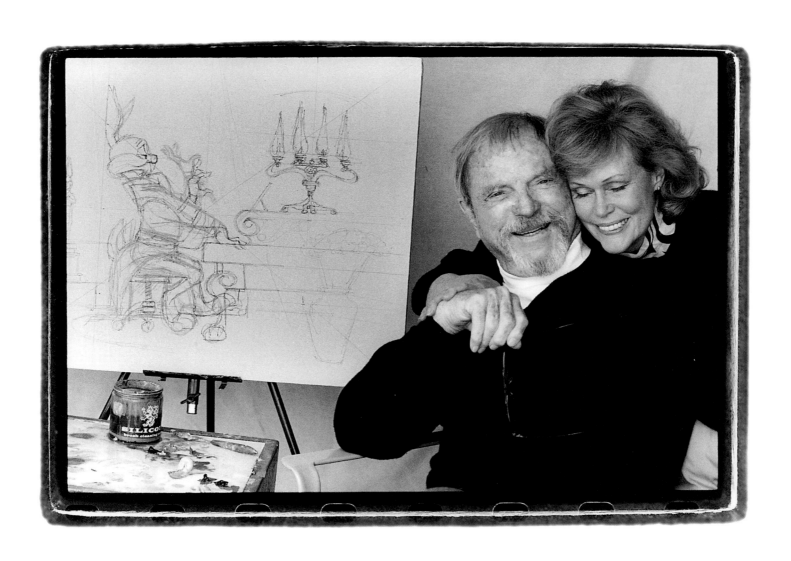

We color away; do math problems; talk sports
and they try desperately to educate me in the ways of Nintendo....
Then Kyle says, "these bugs are going to the cemetery,"
regarding a busload of cartoon bugs
we've all started coloring together.
I smile, not very convincingly. Chris says nothing.
"They're drowning," Kyle says
as he colors the entire bus and its passengers blue.
"There they go. These bugs are going to the cemetery."
Finally I say, "Kyle that's so sad,"
and though I try to sound matter-of-fact and conversational,
I only succeed in sounding glib and patronizing.
Without looking up from the coloring book Kyle replies,
"Well, you know what they say—some of us gotta go…"
"…And some of us gotta stay,"
adds Chris on the other side of me.
I turned to look at him and he's looking right at me—
right <u>through</u> me.
I get the message:
no pity, just progress.
People shouldn't be dying.

—Yeardley Smith

Yeardley Smith with Christopher and Kyle

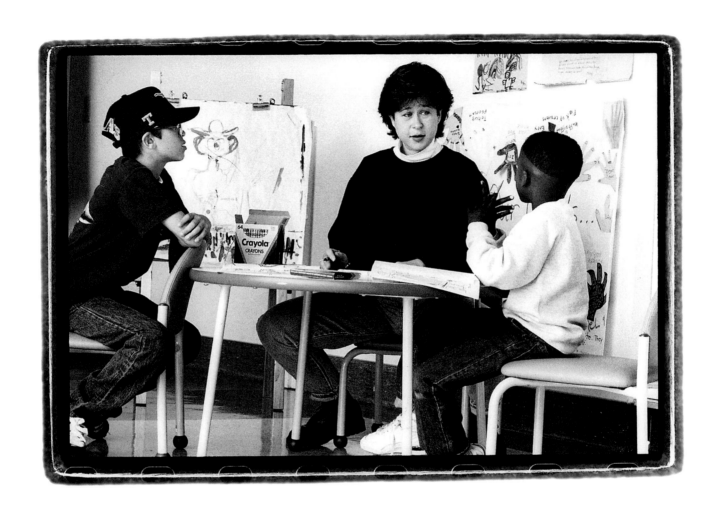

Go for the Gold!!

—Chris Burke

Chris Burke and Peter, Margaret and Jennifer from the Special Olympics

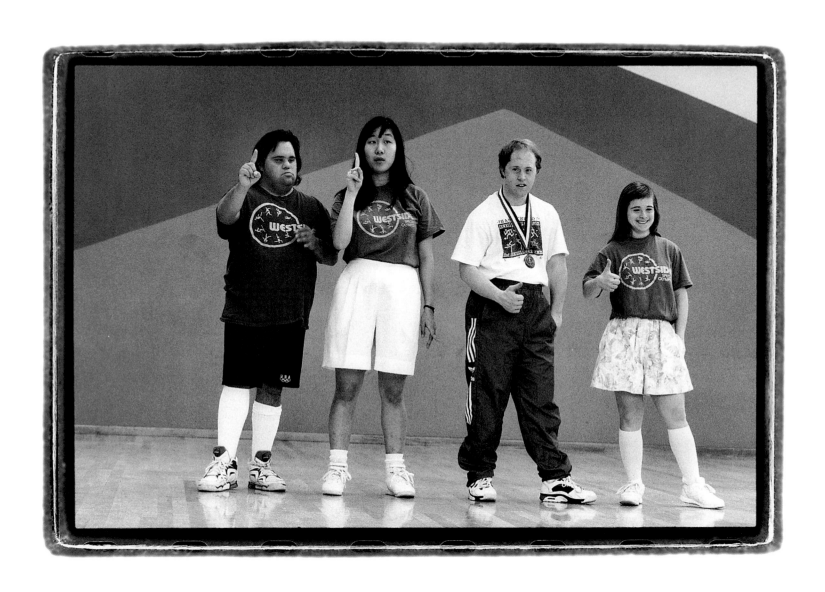

We are for one another.
So let the word go out.
Reach down to lift a child—and reach out to comfort the dying.
And let those who are giants among us carry those too weak....

Until there's a cure,
let there be love.

—Mary Fisher

Mary Fisher, Peter Magowan, the Rev. Cecil Williams, Dusty Baker,
Rod Beck, Royce Clayton and Mary's children Max and Zachary

*These children were shy and very gentle
and they reminded me of Theseus's lines
from Shakespeare's* A Midsummer Nights Dream:

*"Love therefore and tongue-tied simplicity
in least speak most to my capacity."*

—Patrick Stewart

Patrick Stewart and Jonathan Frakes with Lakeisha, Milton, Lynnea and Daniel

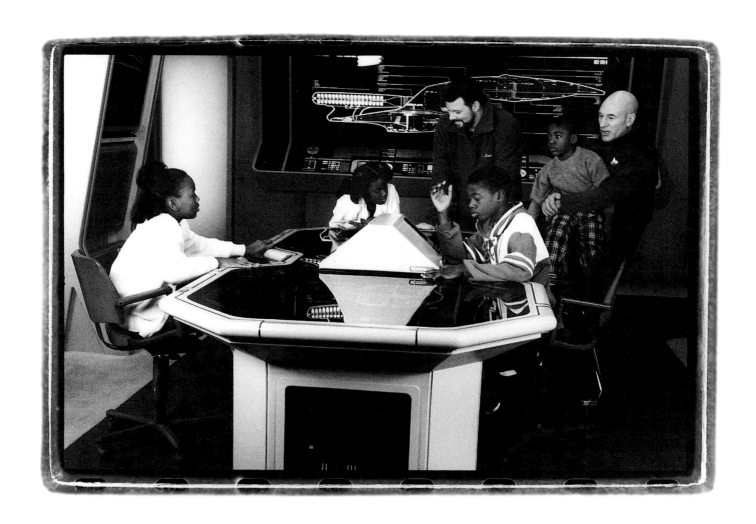

*No man stands as tall
as he who bends
to help a child.*

—Robert Wagner

Robert Wagner and Adrienne and Brent

Being a parent is both sublime and humbling.
My child's joy in the moment,
and the gift of his love,
are teaching me the greatest lessons of my life.

—*Gates McFadden*

Gates McFadden and son James Cleveland McFadden-Talbot and Brent Spiner

Children are dying....

—*Sara Gilbert*

Sara Gilbert with Gabrielle and Brandon

The most important commodity we have for the future
is the children.
So if we as adults are vain enough
to think that we'll always be the ones
to influence the world
then we've already sabotaged our future.

—Charles S. Dutton

Charles S. Dutton and Nikki Moy

Children are a miracle of Love.
Love is the best thing
that can happen to any one of us
on this beautiful earth.
Keep the children safe and happy!!
Please God…Save the children
Please God…
Save all our good people from dying too soon.

—Brenda Vaccaro

Brenda Vaccaro with Tim

*If the children are the
Hope…
then the elderly are our
Wisdom…
We must take care of
both….*

—Edward James Olmos

Edward James Olmos with Dylan and Carolina

*My faith in the future lies mostly in the hearts, souls, minds
and lives of the magnificent children I see all around me,
especially the children of my two brothers
and of my many friends.
Casey Schwartz, the daughter of writer Marie Brenner
and radio giant Jonathan Schwartz, is one of my favorites.
She is my Presidential candidate
for the year 2020 when she'll be 37 years old.
Casey is more certain today that her career lies
in playing first base for the Boston Red Sox.
(She even has her number—42—picked out!)
Perhaps Casey can first play baseball and then eventually
be an American President as well.
She is smart and versatile enough for both.
She has heart and an over-developed sense of social-consciousness.
She has charisma, poise and personality,
and a great all-American name
that should be duck soup for the campaign.
Casey and I both hope that by the time she enters the White House
(naturally with the backing of the Red Sox team and all its fans),
AIDS will be a disease of the past.
If not, Casey's first priority in office will be to make it so!
I might even still be around to applaud.*

—Liz Smith

Liz Smith and Casey

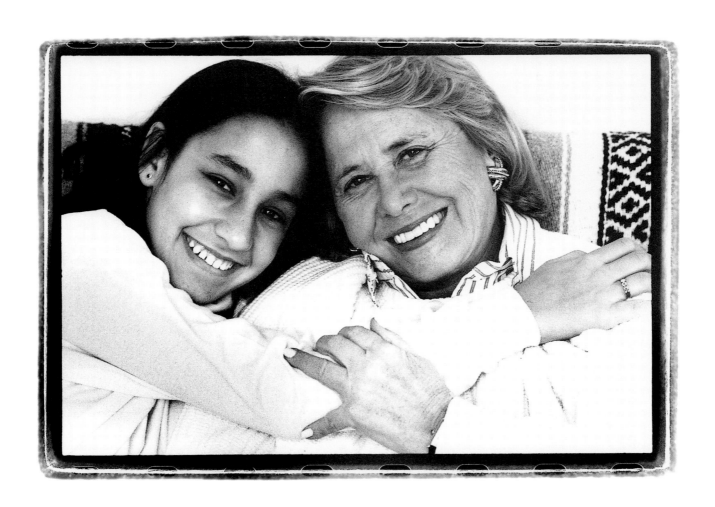

When a parent loves, a child loves.
Acknowledge the gift and there's nothing more to say.
Thank you for loving me....

—Monica Mancini

Henry Mancini and daughter Monica

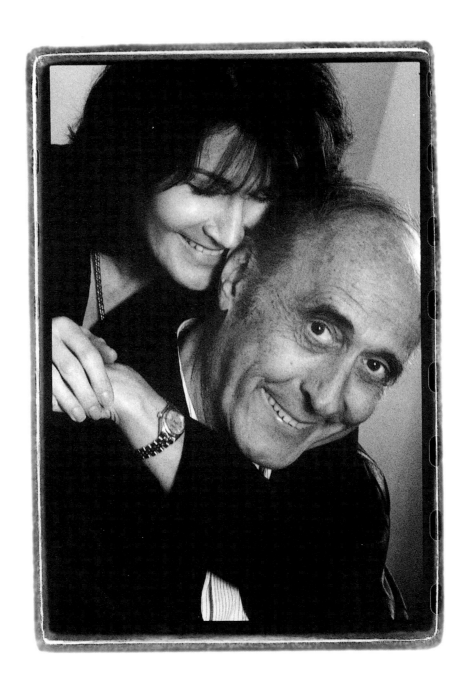

So many of life's problems could be solved
if we would just remember to love the children.
Regardless of who they are
or where they are from,
we must remember to embrace them,
encourage them and nurture them.
They are our future.

—Marlee Matlin

Marlee Matlin and nephew Cory

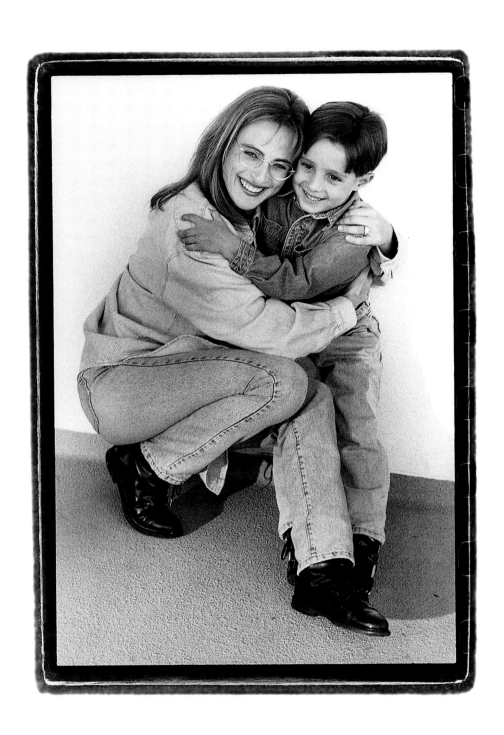

*When Alexis entered the room on the day
we were to take our picture for this book,
she breezed in…
and her energy oxygenized the air.
She is the personification of a bundle of love…
and the hugs she gives with bubbles of enthusiasm
defy any notion that she is unwell.
It is incomprehensible to imagine that this child is HIV-positive.
"What can I do?" the frustration cries out
from our nature to feel we have the power to effect change,
and yet we are powerless in the face of this disease.
At the end of the day, perhaps there is one thing we can do.
We can give love,
perhaps that is our greatest power of all.*

—Stefanie Powers

Stefanie Powers with Alexis

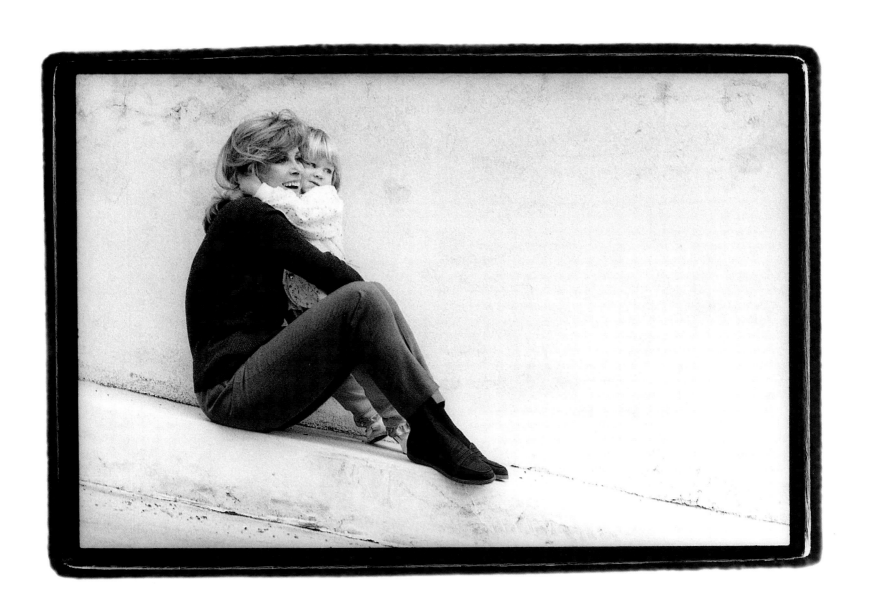

The most precious gifts in life are children....
I feel that it is our duty as adults
to do whatever possible
to see these roses bloom.

—Mark Langston

Mark Langston and daughters Katie and Gabriella

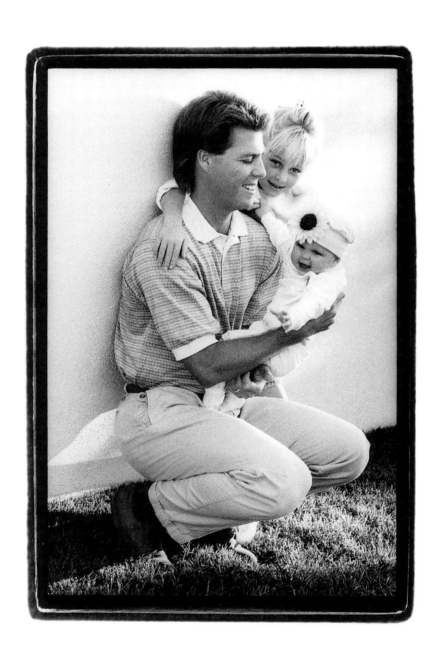

I've learned through my own son and daughter
that we can never know what children know.
There is some kind of a secret wisdom exclusive to the little ones.
In their souls they hold everything that is good and pure
and they share it with us through giggles and smiles.
And if we listen very carefully
sometimes we can hear their truth.
When I played with Meghan,
I heard it.

—Leeza Gibbons

Leeza Gibbons with Meghan

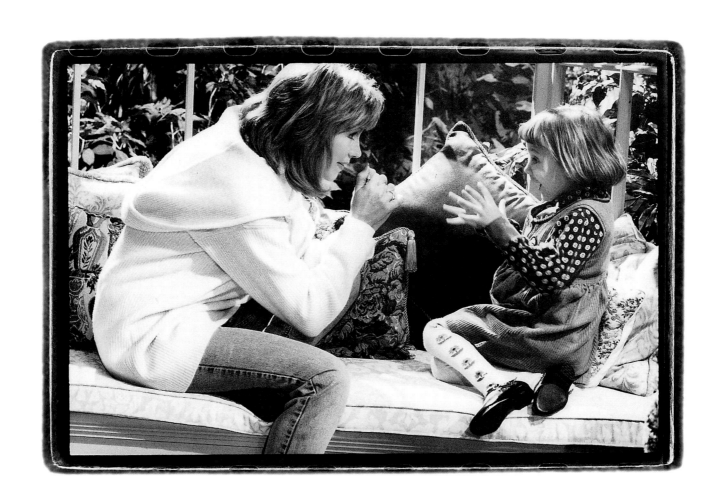

While music inspires our soul—
children fill our hearts
with endless hope.

—Donald Pippin

Donald Pippin and goddaughter Jaime

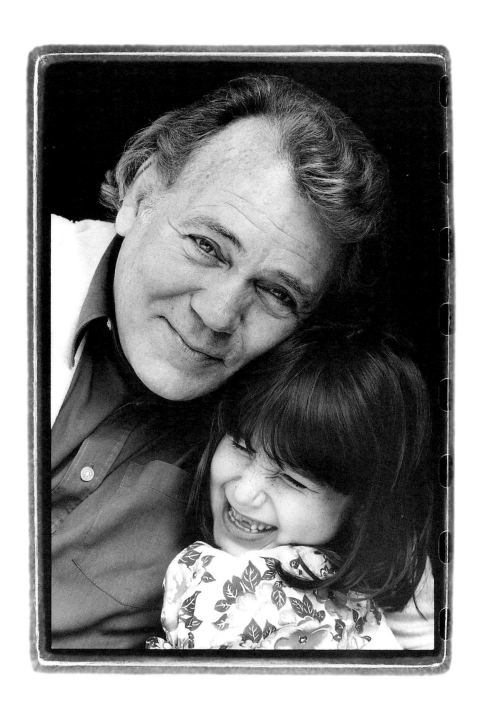

*Bobby, with love
in our hearts
and hope for a cure…
we cherish our memories
and miss you so.
Love always.…*

—Joanna, Ashley, Marty

Joanna Kerns, daughter Ashley and mother Marty

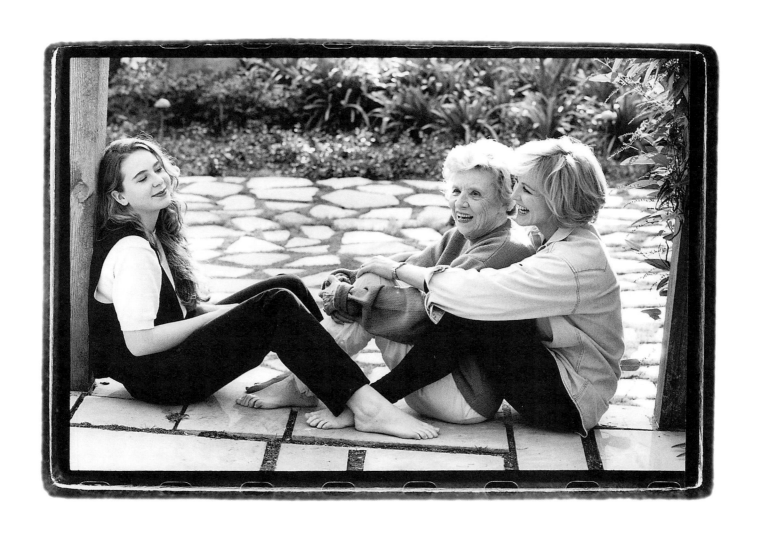

There is nothing more pure
than a child's laughter or a child's tears....

—Diahann Carroll

Diahann Carroll with Noel, Joel and Angel

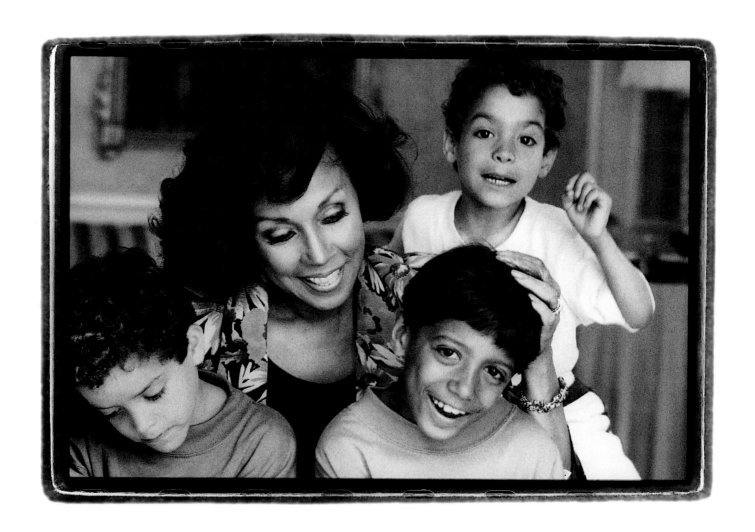

The small child is fresh from God.
Unattached and uncomplicated,
it is inherently kind, loving and curious.
Untethered by greed, prejudice and hatred,
neither the past nor the future
is of great bother to it.
It lives in the moment.
It is our best teacher.

—Dennis Weaver

Dennis Weaver and grandsons Travis and Brandon

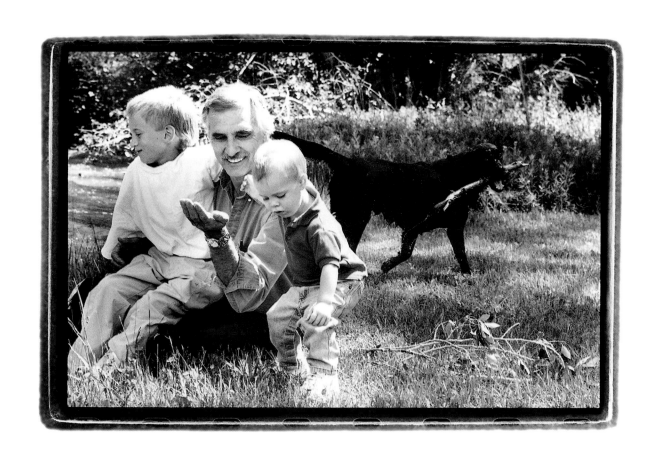

Children bloom like flowers in the light of love.

—Phyllis Diller

Phyllis Diller with Zolan

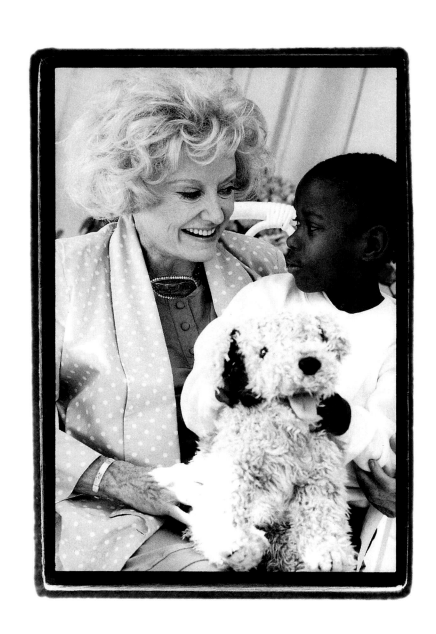

When you educate your child you educate yourself.
Children are your unlived lives.

—Sally Jesse Raphael

Sally Jesse Raphael and son J.J.

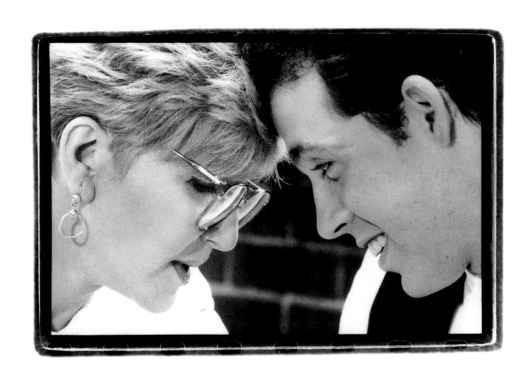

Never take a step backward,
not even to gain momentum.

—Andy Garcia

Andy Garcia with Jessica

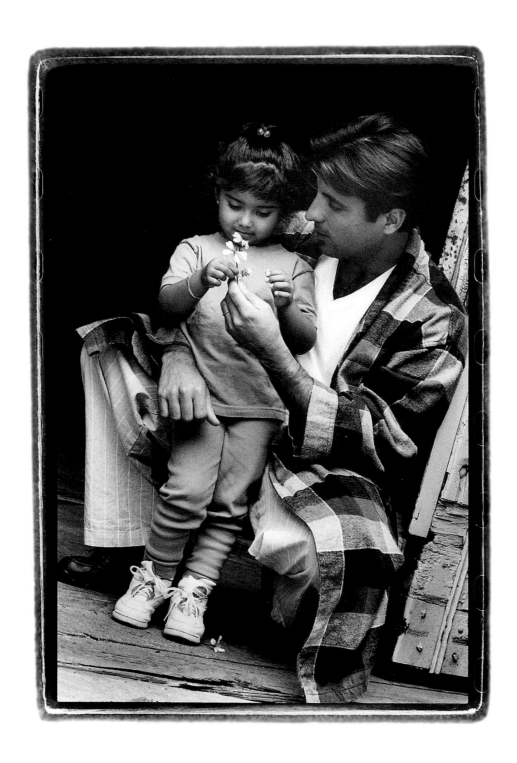

Children do not belong to us.
They are merely on loan to brighten our lives;
an affirmation that the world should continue,
that wonder still exists
and that all things are possible.
If only we could hold on to that wisdom.

—Bruce Davison and Lisa Pelikan

Bruce Davison and Lisa Pelikan

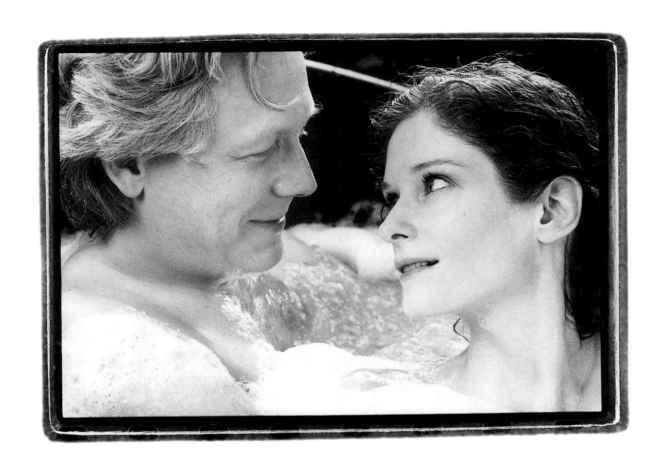

*I'm looking out a large window now
and I see about forty dogwood and maple and oak and locust trees
and the light is on some of the leaves
and it's so beautiful.
Sometimes I'm overcome with gratitude at such sights
and feel that each of us has a responsibility for being alive:
One responsibility to creation, of which we are a part,
another to the creator—
a debt we repay by trying to extend our areas of comprehension.*

—Maya Angelou

Danny Glover and Kevin

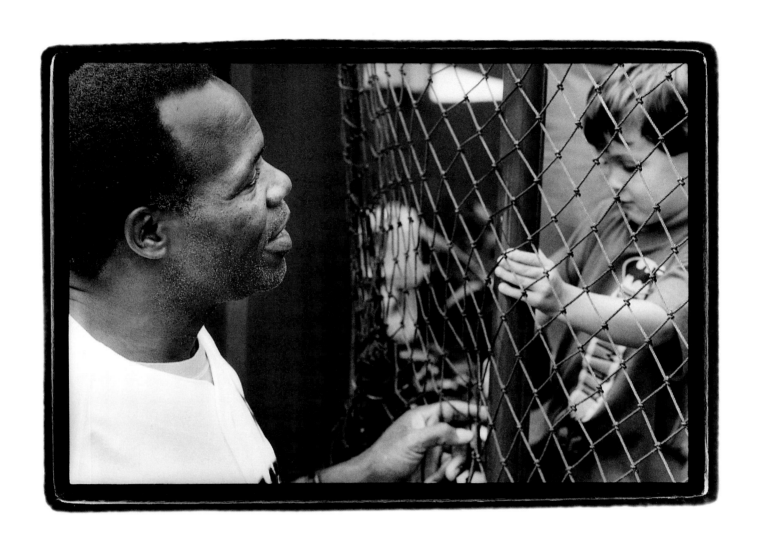

We can easily forgive a child who is afraid of the dark.
The real tragedy of life is when
adults are afraid of the light.

—Plato

Jay Leno with Brandon

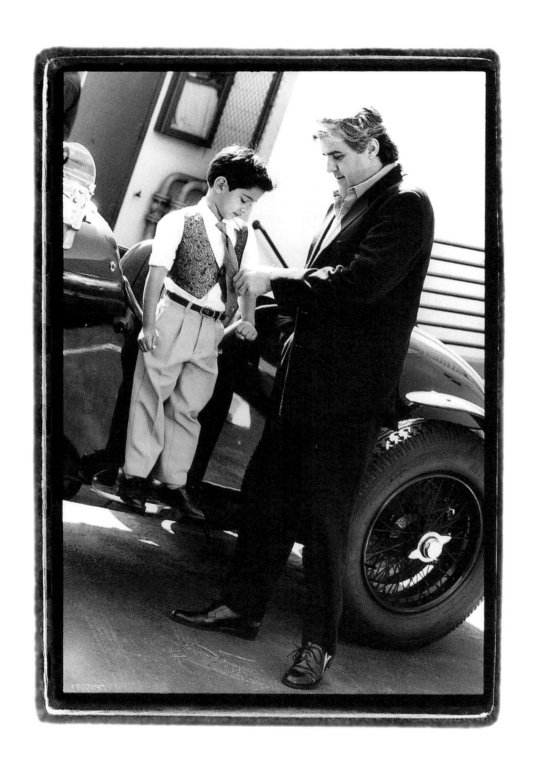

God loves you
we love you
and
you must love yourself.
I believe in you!

—James Brown

James Brown with Katherine

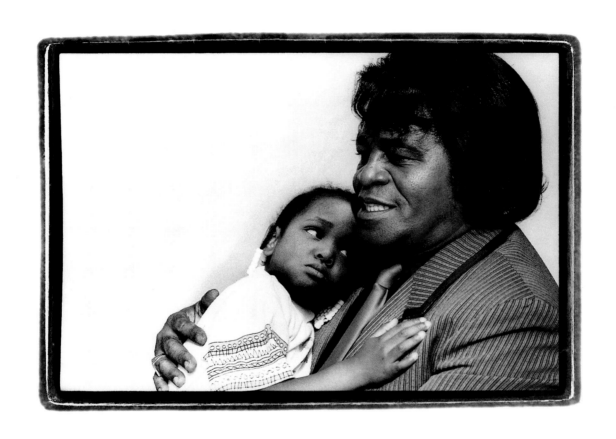

If I can stop one Heart from breaking
I shall not live in vain
If I can ease one Life the Aching
Or cool one Pain
Or help one fainting Robin
Unto his nest again
I shall not live in vain.

—Emily Dickinson 1830–1886

Leanza Cornett with Luis

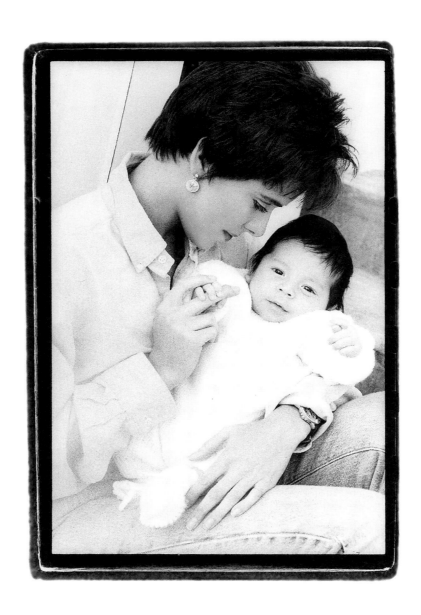

If you ever desire to get
the true meaning and feeling of innocence,
just pick up a child and embrace them, understand?
You'll love it.

—Sugar Ray Leonard

Bernadette and Sugar Ray Leonard

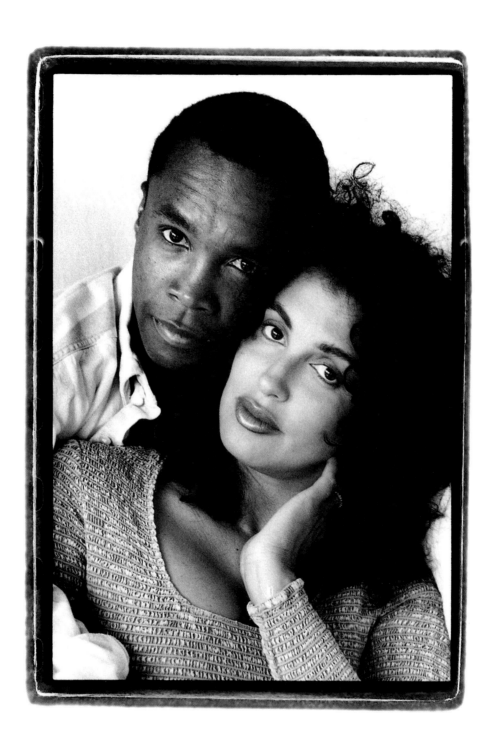

The most important thing we can give
to our children today
is hope.
If we can reach out
to disconnected young people
and inspire within them
a feeling of self-respect and self-love,
they will have a future worth working toward.
We need to transcend our society's innate consciöus
and subconscious racism, sexism, ageism and classism,
to invite everyone to the party!

—*Michael Wolff*

Michael Wolff and Polly Draper

Never bend your head, always hold it high.
Look the world straight in the face.

—Helen Keller

Tom Arnold and Roseanne

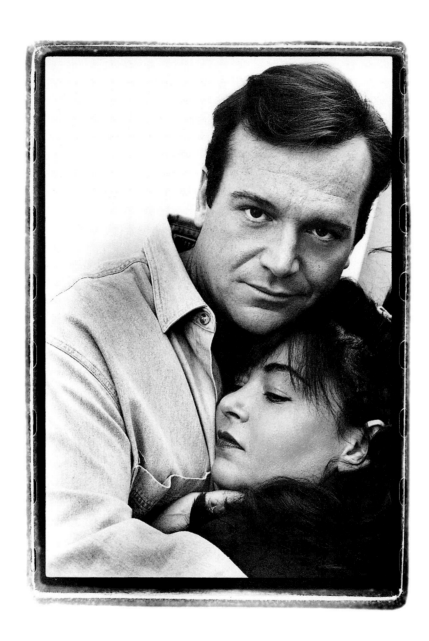

The biggest threat to the survival of humankind is ourselves.
We must stop the spread of AIDS to our children now.
They are our future and hope for a better world.

—Kate Linder

Kate Linder and goddaughter Madeline

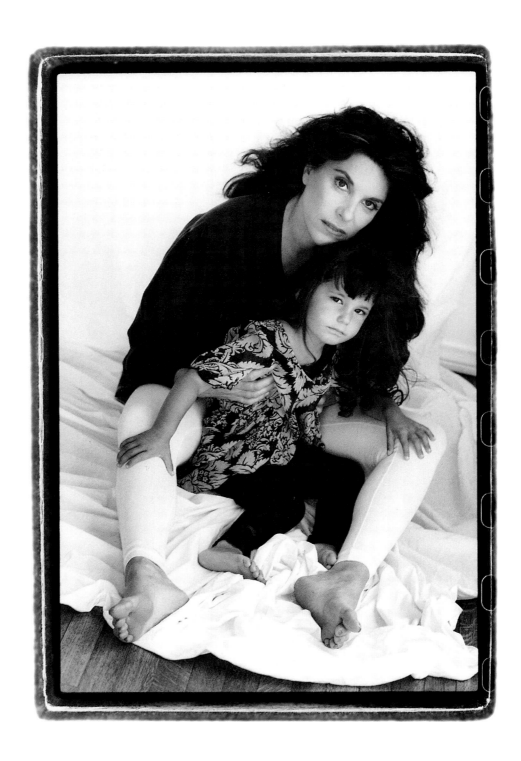

Walk on a rainbow trail;
walk on a trail of song,
and about you will be beauty.
There is a way out of every dark mist,
over a rainbow trail.

—Navajo song

Lou Diamond Phillips and Jennifer Tilly

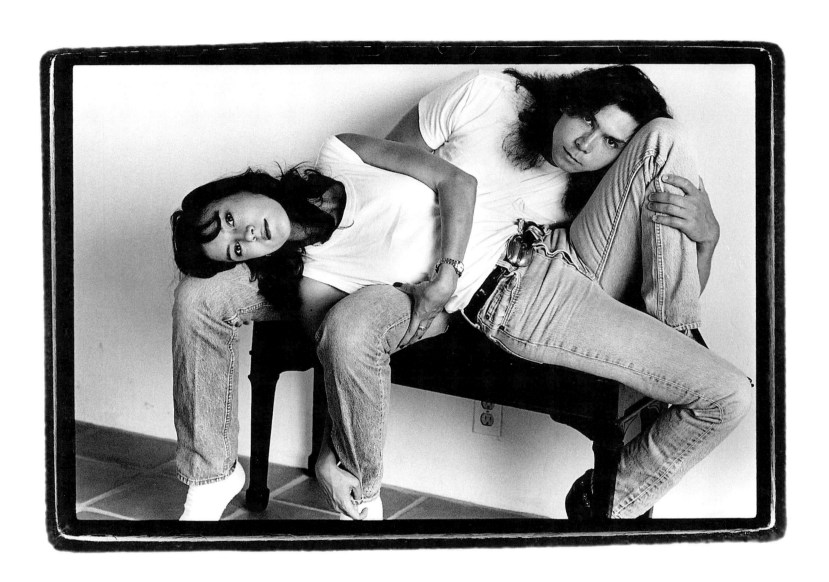

Her angel's face
as the great eye of heaven shined bright,
and made a sunshine in the shady place.

—Edmund Spenser 1552–1599

B. D. Wong and family

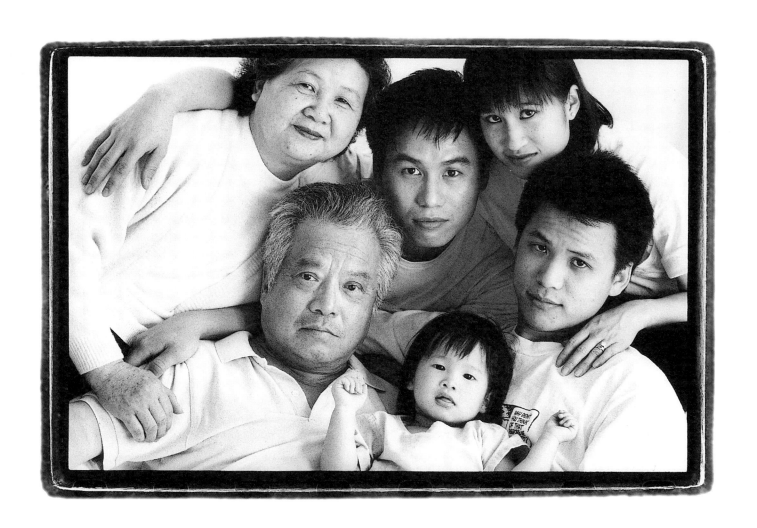

As I live in light
I open my heart to my fears
As I live in love
I embrace my tears
As I live in God
eternity knows no limit of the years.

—Nicollette Sheridan

Nicollette Sheridan with Briah

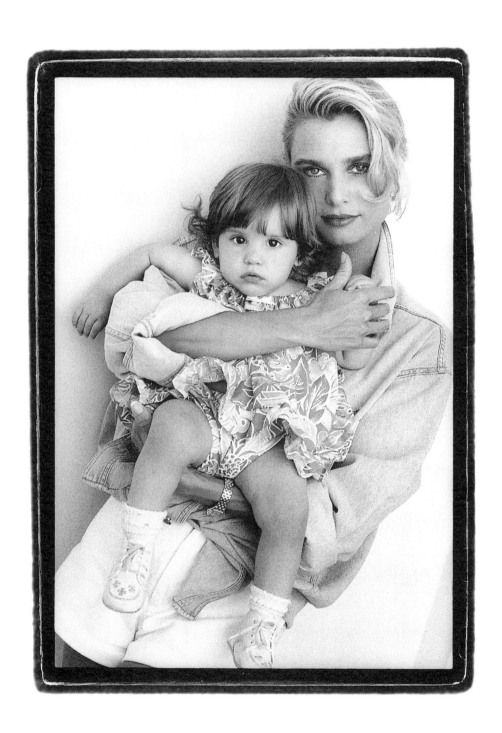

There is a divine moment in our lives
when we all become One.
It is called procreation
and it is reborn, continually and forever,
the future we call children.
They are our legacy. Our responsibility.
They are our destiny and we are theirs.
The extent to which we fail as parents,
we fail as God's children.

—Dirk Benedict

Dirk, Toni Hudson, George and Roland Benedict

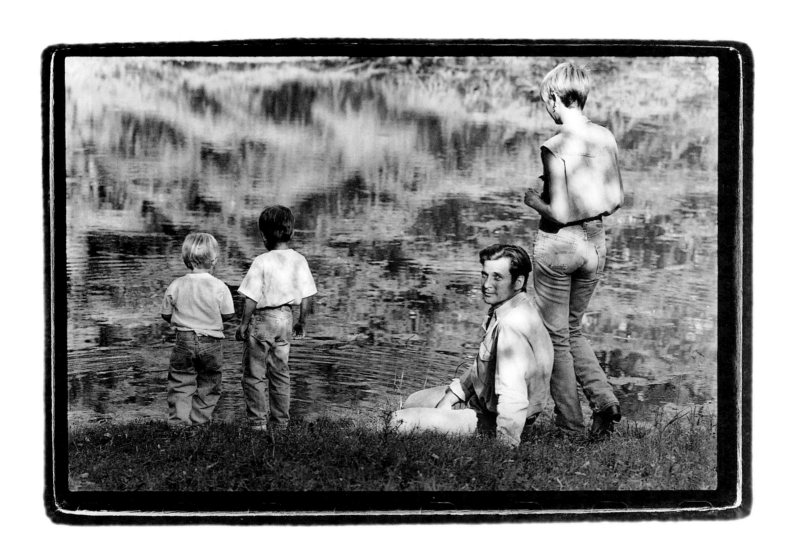

If we were all as pure as our Children, and Music,
we might see the real beauty that life has to offer.
The beauty that is made up of objective opinions
without prejudice or anger
without judgment or criticism
but just for what is.
If we begin by being grateful
for every moment we are alive,
everything else is a gift.
All our Love to all the children in the world....

—Lyndie and Kenny G.

Lyndie and Kenny G. with Raven

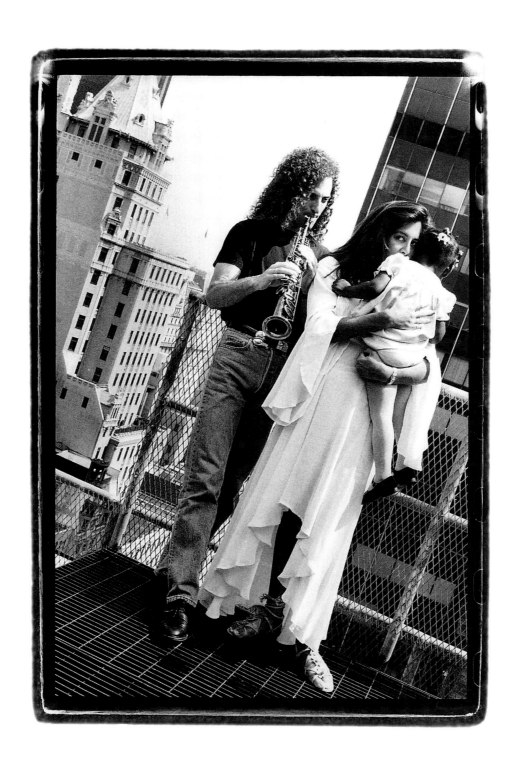

In those moments when I stop trying so hard
to teach my children and allow them to teach me,
I am reconnected to the universe.
This is the gift they give me,
when I let them.

—JoBeth Williams

JoBeth Williams and sons Will and Nick

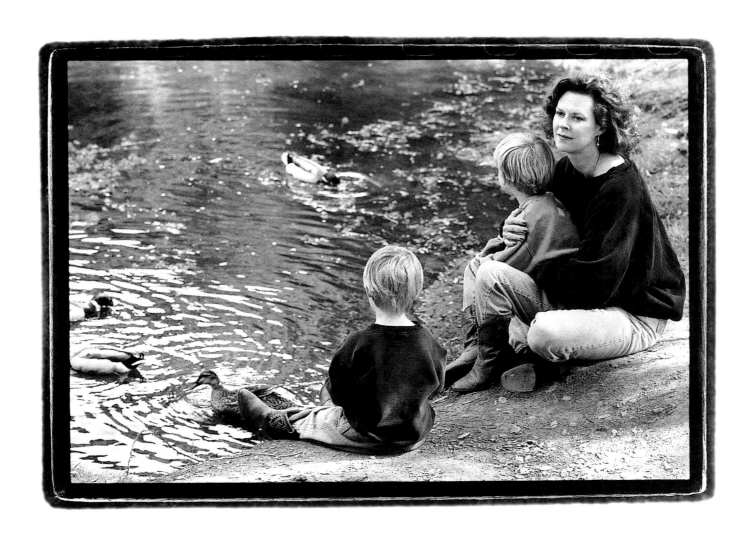

*Our children trust
that we protect them…
and their world.
Love and kindness,
non-violence and nurturing
must prevail….
Let us slow down,
open our eyes
and hearts
and see what each
of us can do—
In the moment
that we are here
on this earth….*

—Joy Stockwell

Joy and Dean Stockwell

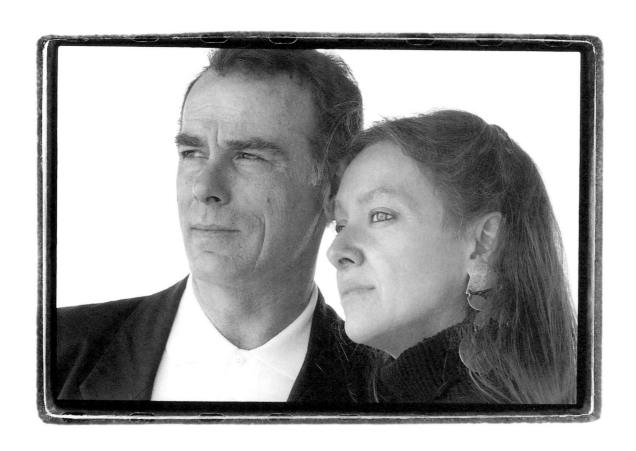

A simple child,
that lightly draws its breath,
and feels its life in every limb,
what should it know of death?

—WIlliam Wordsworth 1770–1850

José Eber with Michael

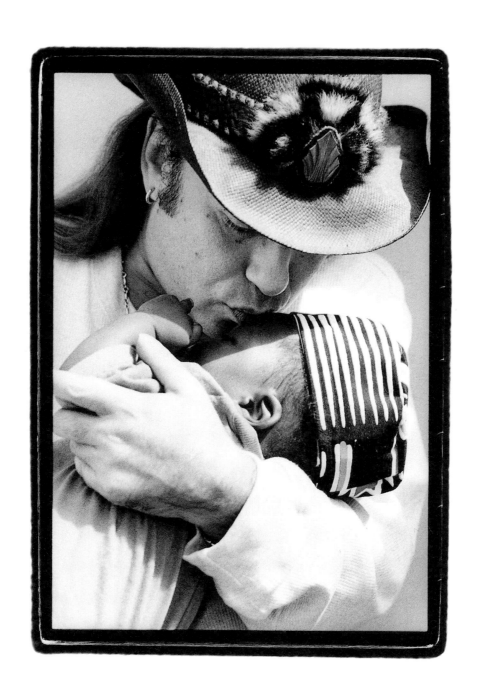

Hard to believe, but true…
someone so tiny can fill your heart with love to overflowing.
Sometimes the biggest love comes in very small packages.

—Maureen McGovern

Nicodemus Bebop Dickens and "mom" Maureen McGovern

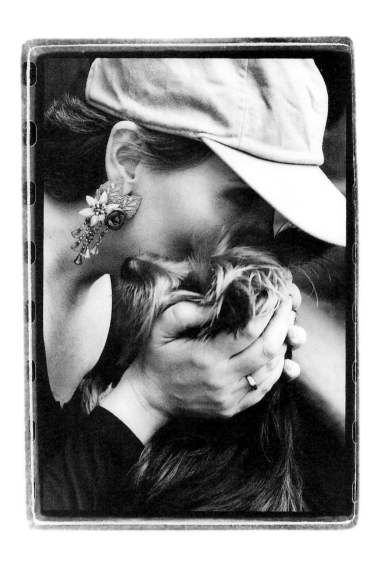

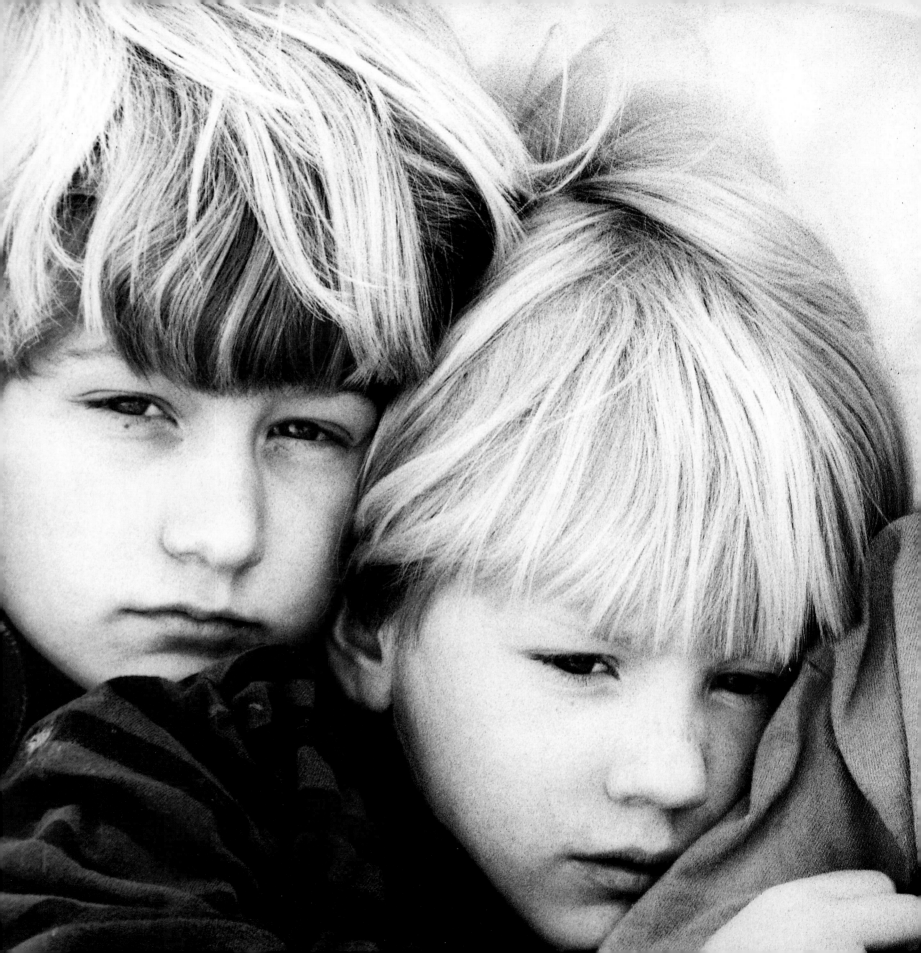

What's done to children, they will do to society.

There's no high-tech medical instrument
that can offer the same compassion as love.
Love really is the best medicine.

—Jeanne Moutoussamy-Ashe

Jeanne Moutoussamy-Ashe with Trevell-Eric

Our job should be,
to beat down the path and
hang lanterns of courage and kindness.
To make it easier for the children
coming behind us to see.

—Michael Keaton

Michael Keaton and pal Kelly Dugan

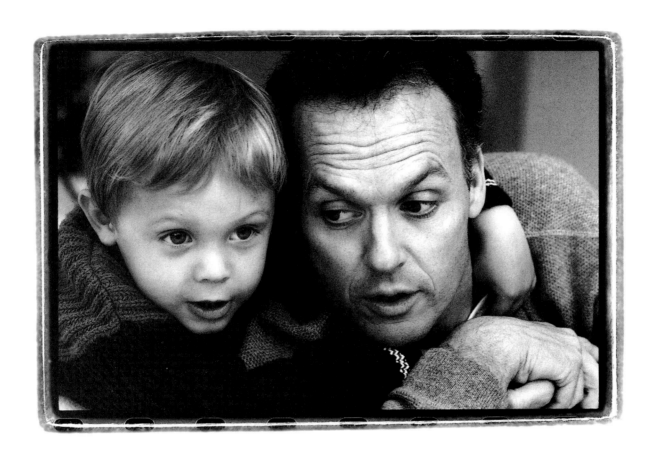

I knew Veronica only long enough to pose for this picture.
I shall love her forever.

—Walter Cronkite

Walter Cronkite with Veronica

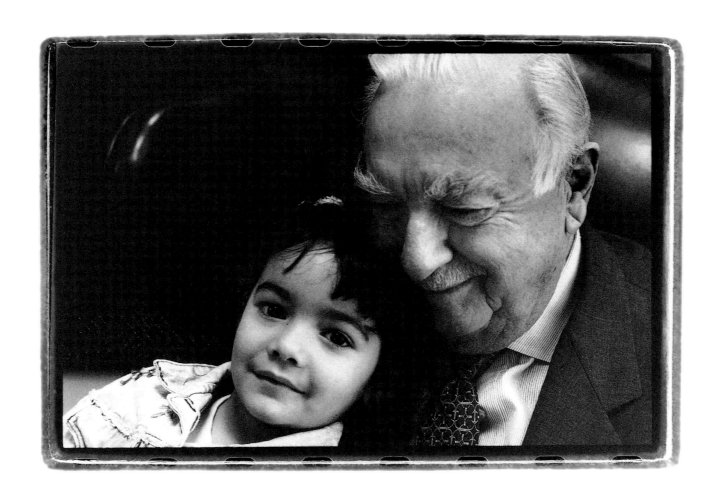

I remember last year, I was teaching
the Heimlich Maneuver
to students in an inner city grammar school
when the segment for questions came up.
I heard a small voice next to me call out,
"How do you give the Heimlich Maneuver to a pregnant girl?"
I turned around and looked
into the face of a twelve-year-old girl
who must have been nine months pregnant.
I immediately began to hold back the tears
when her bright and lovely smile
gave me the strength to continue.
I answered her question and gave her a big hug.
In pediatrics courses in medical school,
we were taught that a child is not a small adult.
Children have unique physical and mental problems
that are their own.
When will a thousand people follow me into the inner city,
put their arms around a child, say "I love you,"
and help these wonderful children
reach their full capabilities?

—Dr. Henry J. Heimlich

Dr. Henry J. Heimlich

AIDS does not discriminate.
Our children will soon live in an environment
where the most loving act may kill them.
Now more than ever, we need to learn to put aside fear, ego,
religious and traditional belief systems
so we can tackle the most debilitating disease of our time.
We must do this so our children can embrace a future.

—Donna de Varona

Donna de Varona and her children John David and Joanna

Children carry not only the genes, dreams and aspirations
of their parents, but the whole bloodline of the Human Race.
Each child is not only the beginning of a new life,
he or she is also all that we have been,
becoming all that we can be…
self-generative Life
evolving through us
into its own higher purpose.

—Ellen Burstyn

Acting grandmother Ellen Burstyn with Gabrielle

*In the eyes of a child
shines the wisdom of generations....*

—daughter of John and mother of John Jr.

John Forsythe and grandson John Jr.

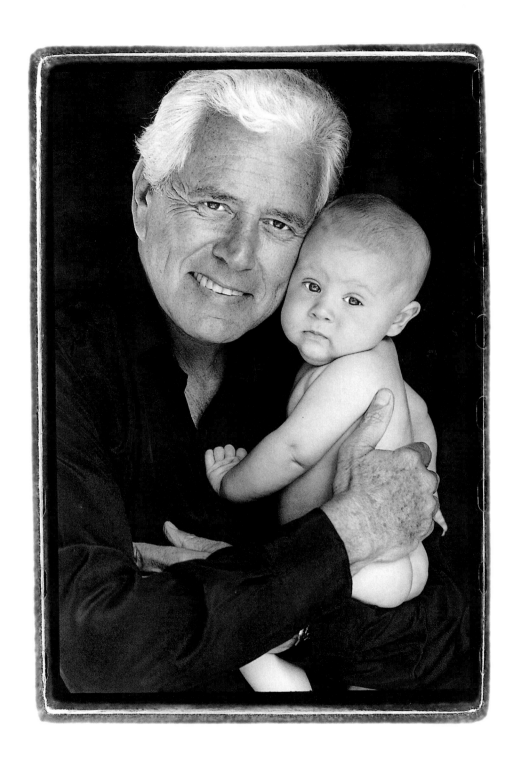

With Love

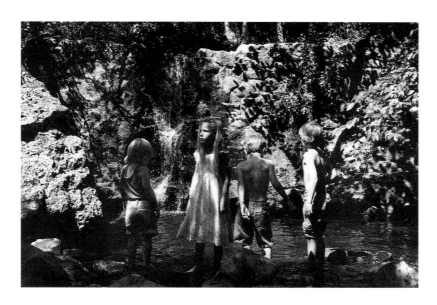

I have lost
so many friends
to this terrible disease.
None of us can rest
until it has been
eradicated.

Julie Andrews

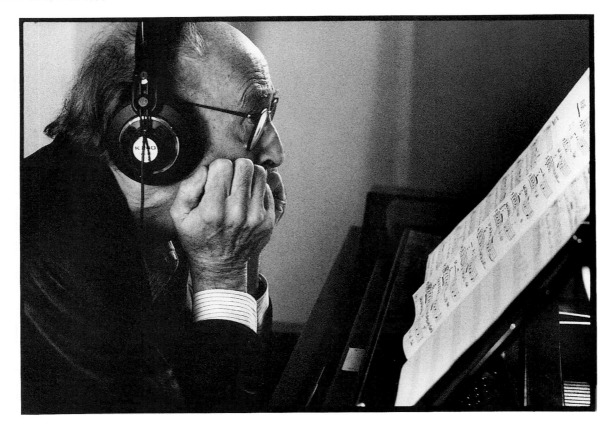

With Love

Music by Henry Mancini
Lyrics by Will Jennings
Produced by Richard Warren

With love, anything is possible
With love everything is fine
New worlds are spinning every day
Miracles are on the way
In every touch and word you say

With love, our lives begin with love
Time makes a place and we come in
We grow and try and lose and win
We all begin with love
We make it right with love

We rise and shine from where we are
From heart to heart and star to star
We make the light with love
When we wander in the dark
And we know we've gone too far

Love is all we really have
To show us where we really are!
Going out and coming in
We are souls against the wind
Love is all we really have
to see us safe until the end
It's the best of you and me
It's as fine as we can be

When we look beyond ourselves
That's when our eyes can really see
We can make the light with love
We can make it right with love
Life is possible each day
Our hearts will light the way

With love, With love, With love

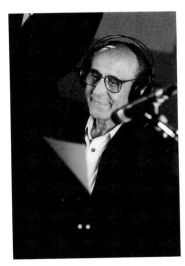

For generations, Henry Mancini has created the singularly identifying signature for many of our most memorable films and their lead characters. In that way, Hank's music identified himself as much as it did the work. Smooth, lyrical, poetic, classy...easy to hum and hard to forget.

When I first became involved with the Hands On Care Foundation through its creator, Joan Lauren, and her book, *PORTRAITS OF LIFE, With Love*, it was to help put on a gala event to celebrate the book. My first thought was that what would make this organization unique among all the others that are also doing such wonderful work for those living with HIV/AIDS, would be to have its own song. A signature song—a HENRY MANCINI song.

So I went to see Hank. I only had to ask once, and it was a done deal. His only concern was who would write the lyrics. I told him it had to be someone who could convey the love, the passion, the dreams of those living with HIV/AIDS and those of us working to help give them a better life, a chance at a longer life. For Hank, there was only one man to do this: Will Jennings. Henry had worked with Will on other projects and wanted to work with him again on this one.

So I spoke to Will on the phone and told him briefly about the project. We made arrangements for him to meet with Joan, Bruce and myself later in the week. When we arrived at his home a few days later, Joan told him the history of the project. After a few minutes he excused himself and came back moments later with a piece of paper. On it were the lyrics for the song. It was a magical moment for all of us

Will Jennings

But by this time, Henry had become very ill. He was diagnosed with inoperable cancer. When I spoke with him he told me he wanted to be there to record the song, to have his daughter, Monica, sing it for us. The cancer was stripping him of much of his strength, though, and he needed time to rest. There were considerations of time, but I decided to wait for Hank, I could not go into the studio without him. Weeks passed. Hank finally said that if I had to go in and get it done it was all right with him, but if I could wait a little longer, he still might do it himself.

So I waited another week. And then I spoke to Hank, and he said let's do it now. I had not seen Hank for almost two months, and his illness had taken a terrible toll. I helped him up from the couch, and he slowly walked over to the piano. He sat down, and God sat down with him. All the vitality and beauty he had carried with him through life came through his fingertips as the song was brought to life for the first time. We sat in the booth, Joan, Will, Bruce and I, and we listened, and we cried. It was there and it was incredible. Monica's voice was brilliant. It was more than I had dared dream for.

This was the last song Hank wrote and the last time he was in a recording studio. He could not have left a more fitting epitaph to a remarkable career, and an even more remarkable life. There are those whose lives will be more than they might ever have been because of this song. Those who will be moved to act and those who will benefit. One more time, Henry has touched the lives of those around him.

We are all a little better off for his having been on this Earth. I will remember Henry as a friend, a mentor, as a man to emulate. I will try to give others what he has given me. And I will look forward to once more seeing his smile, to hearing his next song. If I close my eyes really tight and listen really hard, it's there. I can hear it. Can't you?

Thanks Hank. Thanks a lot, for everything.

Rich Warren
Producer, "With Love"

Richard Warren, Monica and Henry Mancini

EPILOGUE

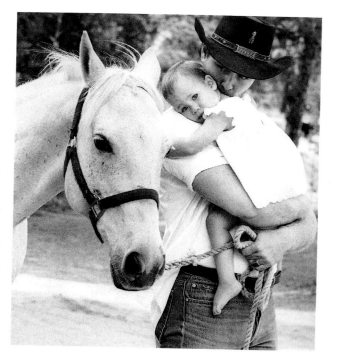

*The greatest sins of our time
have not been by those that have created great devastation,
but rather those that have sat idly by and watched.*
—*The Reverend Dr. Martin Luther King, Jr.*

Historically, the human race has let the fear that accompanies unfamiliarity rule the paths they and their descendants have taken in their lifetimes. This is surprising when you consider the fact that those who have given the greatest contributions to mankind and its future generations are the individuals who faced fear and exposed the light of education to controversial topics. Galileo, Moses, Mother Teresa, The Reverend Dr. Martin Luther King, Jr., Susan B. Anthony, Oskar Schindler, Margaret Kaupuni, Wendy Arnold, Ninoy Aquino, Harriet Tubman, The Reverend Dr. Mel White, Dian Fossey, Mohandas Gandhi, Audrey Hepburn, Annie Sullivan, Helen Keller and our Lord Jesus Christ encouraged us to seek the light of truth.

All too often, we try to disguise or hide the less attractive attributes of today's society by instilling fear of the unknown in the hearts of our young during their formative years. By doing so, we stunt their intellectual growth. A child can never reach his or her full potential by ignoring what previous generations have taught us to avoid with fear by placing in the shadows of the mind the very thing that should be exposed to the light of understanding. With this light in front of them, our children can see what obstacles lie ahead, learn from them and go beyond them.

The variety of emotions and insightful statements about life in *Portraits Of Life, With Love* is just one of the ingredients that make this book so unique. It has been said that some things you see with your eyes, others you see with your heart. We hope that within these pages you've experienced both. This project is unique in that it not only visually stimulates you, but allows you to listen to the voices of our children and more importantly THINK about their needs in our ever-changing world. If whoever picks up a copy of this book doesn't walk away with a new perspective on our children, then despite how much money we raise, we have failed to do the most fundamental task—to educate. *Portraits Of Life, With Love* transcends all boundaries of race, religion, politics, sex and stations in life. It unites from all backgrounds in the one and only responsibility we all share—the health, education and welfare of our children, all children, whether sown of our own seeds or offspring of family or foe.

John F. Kennedy once said that our youth were our greatest natural resource. Never has this been more evident to me than when my brother, Roger, placed my niece, Krystal Carol, in my arms for the first time. In those precious blue eyes I saw the poetry of my great-grandmother, Edna Boll, the wisdom of my grandfather, Gerald Davis, my mother's beauty and the James Dean rebel qualities my father and brother share. Within the confines of this little bundle were the best of the past and the dreams of the future. What we

instill in them as they grow (Knowledge, Respect, Love, Trust and Faith) is what they will instill in their children. I have since become an uncle a second time with my nephew Joshua James. I realize how things I do now could personally affect the world they will inherit from me when I am actually borrowing it from them. I pray that I have the foresight to listen to the messages that my niece and nephew's innocence imparts before it fades into young adulthood.

I am reminded of a story I would like to share:

As an old man walked the beach at dawn, he noticed a child ahead of him picking up starfish and flinging them into the sea. Finally catching up with the youth, he asked why he was doing this. The answer was that the stranded starfish would die if left out in the morning sun. "But the beach goes on for miles and there are millions of starfish," countered the man.. "How can your effort make any difference?" The child looked at the starfish in his hands and then threw it to the safety of the waves. "It makes a difference to this one," he said.

I would ask you to remember that there are many children "starfish" that need you. Please make a difference to one of them.

It is with great appreciation that I thank those who took the time to respond to a letter or a phone call and be part of this project in whatever way they could. They have proven that collectively, we can give a voice to our children—our future! Together we can turn an already bright light into a beacon to guide our youth down whatever road or path they may find themselves.

God bless you!!

Bruce Harlan Boll
Producer/Artist Coordinator
PORTRAITS OF LIFE, With Love

Let all your deeds
be done with love.
—1 Corinthians 16:14

The Hands On Care Foundation (HOCF), which is a 501(c)3 tax-exempt charitable organization, was formed to raise funds to provide support for children living with HIV/AIDS and their families. The Hands On Care Foundation will provide financial support to HIV/AIDS summer camp programs and to direct "hands on care" service-providing and educational organizations (no research) that offer assistance to these children and their families.

The Hands On Care Foundation has formed a partnership with **The National Community AIDS Partnership (NCAP)**, a 501(c)3 tax exempt charity. NCAP has a national network in place to provide financial assistance to persons with HIV/AIDS, and it has the necessary infrastructure to follow through with the development of programs that meet HOCF's criteria.

NCAP will be responsible for distributing HOCF's royalties raised by this book through their grant making programs.

For information regarding the **Hands On Care Foundation Fund**, please write to:

The National Community AIDS Partnership
1140 Connecticut Avenue, N.W., Suite 901
Washington, D.C. 20036

For questions regarding HIV/AIDS, the Hands On Care Foundation would like to offer the following numbers supplied by the **Centers for Disease Control and Prevention (CDC)**.
They are the public access voice for the National AIDS Information and Education Program.

The **CDC National AIDS Hotlines (CDC NAH)** are:

1-800-342-AIDS or 1-800-342-2437

CDC NAH serves as a primary resource for HIV/AIDS information, education and service referrals for the United States. CDC NAH information specialists are trained to answer calls in a calm, caring manner and to provide confidential, individualized answers to callers' questions.

Spanish Service: 1-800-344-7432

Spanish information specialists are bilingual and bicultural. They understand and can communicate with persons from a variety of Hispanic communities. Free Spanish publications are available.

TDD/For the hearing impaired: 1-800-243-7889

TDD information specialists are fluent in both English and American Sign Language (ASL). They understand the cultural differences which exist within the Deaf community. Spanish speaking specialists are also available through the TDD service.

For further information please contact:

HANDS ON CARE FOUNDATION
P.O. Box 46097
Los Angeles, California 90046

Under IRS rules the purchase of this book is treated as a purchase of fair market value. Accordingly, the purchase of this book will not entitle the purchaser to a charitable tax deduction. However, through the Hands On Care Foundation Fund, when you purchase *PORTRAITS OF LIFE, With Love* you will be supporting children living with HIV/AIDS.